深瀬昌久《鴉》

Masahisa Fukase
Ravens

mackbooks.co.uk

MACK
May 2017

Summer 2017

Front

Back

Words

Pictures

Front cover:
**Namsa Leuba, *Huawua*,
2015, from the series *NGL***
*NGL, an acronym for "Next
Generation Lagos," explores
the innovation and creativity
of Nigeria's youth culture*
Courtesy the artist and Art
Twenty One, Lagos

Visit aperture.org for a
series of web-exclusive
features on "Platform Africa,"
produced in collaboration
with C& – Platform for
International Art from African
Perspectives.

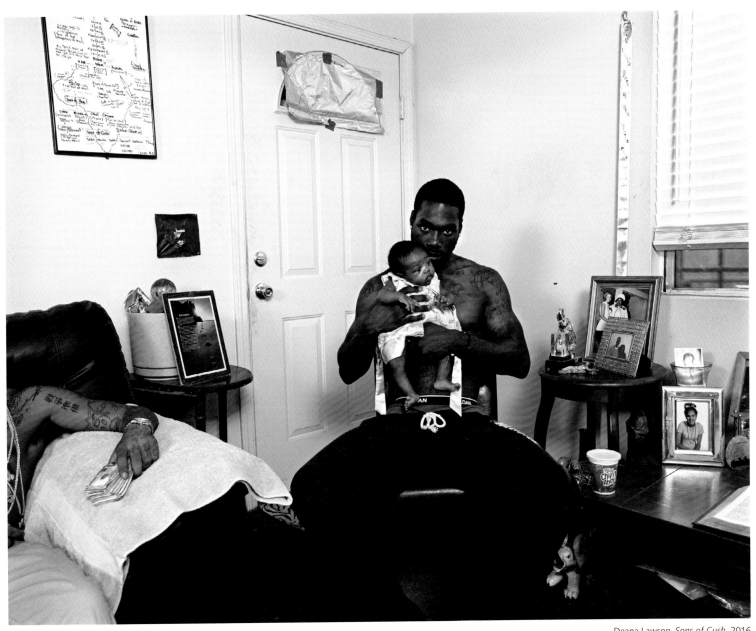

Deana Lawson, *Sons of Cush*, 2016

Deana Lawson

WHITNEY BIENNIAL 2017
MARCH 17–JUNE 11, 2017

RHONA HOFFMAN GALLERY
APRIL 21–MAY 26, 2017

RHONA HOFFMAN GALLERY
118 NORTH PEORIA STREET CHICAGO ILLINOIS 60607 WWW.RHOFFMANGALLERY.COM

Aperture, a not-for-profit foundation, connects the photo community and its
audiences with the most inspiring work, the sharpest ideas, and with each other—
in print, in person, and online.

Aperture (ISSN 0003-6420) is published quarterly, in spring, summer, fall, and winter,
at 547 West 27th Street, 4th Floor, New York, N.Y. 10001. In the United States,
a one-year subscription (four issues) is $75; a two-year subscription (eight issues)
is $124. In Canada, a one-year subscription is $95. All other international subscriptions
are $105 per year. Visit aperture.org to subscribe. Single copies may be purchased
at $24.95 for most issues. Subscribe to the Aperture Digital Archive at aperture.org/archive.
Periodicals postage paid at New York and additional offices. Postmaster: Send address
changes to Aperture, P.O. Box 3000, Denville, N.J. 07834. Address queries regarding
subscriptions, renewals, or gifts to: Aperture Subscription Service, 866-457-4603
(U.S. and Canada), or email custsvc_aperture@fulcoinc.com.

Newsstand distribution in the U.S. is handled by Curtis Circulation Company,
201-634-7400. For international distribution, contact Central Books, centralbooks.com.
Other inquiries, email orders@aperture.org or call 212-505-5555.

Help maintain Aperture's publishing, education, and community activities by joining our
general member program. Membership starts at $75 annually and includes invitations to
special events, exclusive discounts on Aperture publications, and opportunities to meet
artists and engage with leaders in the photography community. Aperture Foundation
welcomes support at all levels of giving, and all gifts are tax-deductible to the fullest extent
of the law. For more information about supporting Aperture, please visit aperture.org/join
or contact the Development Department at membership@aperture.org.

Library of Congress Catalog Card No: 58-30845.

ISBN 978-1-59711-419-6

Printed in Turkey by Ofset Yapimevi

Special funding for the "Platform Africa" issue of Aperture magazine is provided by
Lawrence B. Benenson, Diane and Charles Frankel, and the Tierney Family Foundation.
Further generous support is provided in part by the Anne Levy Fund, and public funds from
the New York State Council on the Arts with the support of Governor Andrew M. Cuomo
and the New York State Legislature, and the New York City Department of Cultural Affairs
in partnership with the City Council.

OFSET
YAPIMEVİ

aperture

The Magazine of Photography and Ideas

Editor
Michael Famighetti

Contributing Guest Editors
Aïcha Diallo, John Fleetwood, Bisi Silva

Managing Editor
Brendan Wattenberg

Editorial Assistant
Annika Klein

Copy Editors
Clare Fentress, Donna Ghelerter

Production Director
Nicole Moulaison

Production Managers
Nelson Chan, Bryan Krueger

Work Scholars
Emma Kennedy, Angelina Lin, Jasphy Zheng

Art Direction, Design & Typefaces
A2/SW/HK, London

Publisher
Dana Triwush
magazine@aperture.org

Director of Brand Partnerships
Isabelle McTwigan
212-946-7118
imctwigan@aperture.org

Advertising
Elizabeth Morina
917-691-2608
emorina@aperture.org

**Executive Director,
Aperture Foundation**
Chris Boot

Minor White, Editor (1952–1974)

Michael E. Hoffman, Publisher and Executive Director
(1964–2001)

aperture.org

FONDATION D'ENTREPRISE **HERMÈS**

THE HERMÈS FOUNDATION IS PROUD TO ANNOUNCE

CLAUDE IVERNÉ

Winner of the Henri Cartier-Bresson Award 2015

EXHIBITIONS

PARIS
FONDATION
HENRI CARTIER-BRESSON
MAY 11 - JULY 30

NEW YORK
APERTURE GALLERY
SEPTEMBER 15 - NOVEMBER 9

FONDATION
H·C·B
Henri Cartier-Bresson

aperture

WWW.FONDATIONDENTREPRISEHERMES.ORG

WE HAVE A DIFFERENT WAY
OF LOOKING AT **AUCTIONS**

Find something new at Swann Auction Galleries. Our departments assemble sales that are unusually rich. In fact, we were the first American house to offer auctions of photographs, and our Photographs & Photobooks specialists remain innovators in their field. Swann understands more than art and books, we understand you, whether you're a lifelong collector, a first-time buyer, or looking to sell. We approach auctions with a blend of high-brow knowledge and low-brow fun. For a different perspective on auctions, come to Swann. We create our own culture.

SWANN
AUCTION GALLERIES
APERTURE 6

104 East 25th St, New York, NY 10010 • 212 254 4710 • **SWANNGALLERIES.COM/PHOTOGRAPHS**

Agenda
Exhibitions to See

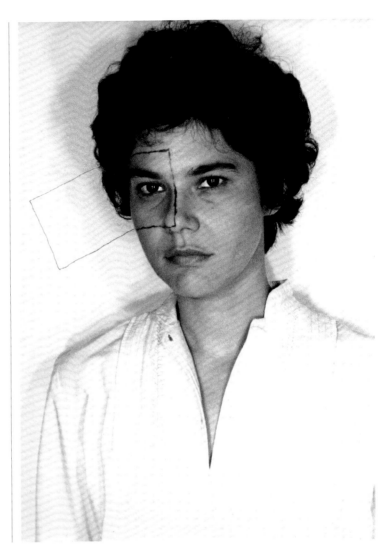

Radical Women at the Hammer Museum

As part of the Pacific Standard Time: LA/LA initiative, which will involve dozens of museums across Southern California, the Hammer will open a survey of more than one hundred female Latin American artists. *Radical Women: Latin American Art, 1960–1985* focuses on a turbulent twenty-five-year period when much of Latin America suffered under forms of military dictatorship, and the emboldened work of female artists, in particular, challenged the status quo. While the work ranges across a wide variety of practices, a number of important artists celebrated for their photography, including Liliana Porter, Regina Silveira, and Paz Errázuriz, will be featured.

Radical Women: Latin American Art, 1960–1985 at the Hammer Museum, Los Angeles, September 15– December 31, 2017

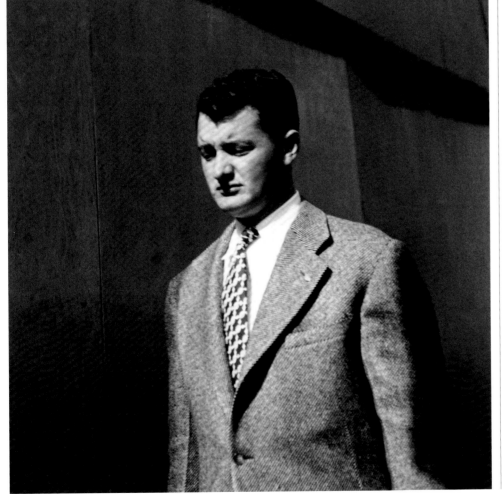

Left:
Walker Evans, *Male Pedestrian in Tweed Coat, Detroit,* for *Fortune* magazine article "Labor Anonymous," 1946
© Walker Evans Archive, the Metropolitan Museum of Art, and courtesy Art Resource, New York

Above:
Liliana Porter, *Untitled (Self-Portrait with Square),* 1973/2012
© and courtesy the artist

Walker Evans at the San Francisco Museum of Modern Art

A major retrospective of Walker Evans's vernacular style comes to San Francisco this fall and will include more than three hundred works from the 1920s to the 1970s that illuminate the seminal photographer's facility for capturing the everyday. SFMOMA will mount the exhibition's only U.S. engagement, following a presentation at Centre Pompidou. The museum's new senior curator of photography, Clément Chéroux, curates a textured look at Evans's practice, including not only his photographs, but also personal items such as postcards and clipped images that influenced him.

Walker Evans: A Vernacular Style at the San Francisco Museum of Modern Art, September 23, 2017– February 4, 2018

Albert Renger-Patzsch at Jeu de Paume

This exhibition of 190 photographs marks one of the largest to date of the work of photographer Albert Renger-Patzsch, a crucial figure in the New Objectivity movement during the Weimar Republic in 1920s Germany. In his stark images of nature, architecture, and commercial items— from orchids to shoe-factory machinery— Renger-Patzsch sought to precisely depict the "essence of the object." His 1928 photobook, *Die Welt ist schön* (The world is beautiful), helped define the movement. *Albert Renger-Patzsch: The Perspective of Things* will also include a selection of the photographer's postwar works.

Albert Renger-Patzsch: The Perspective of Things at Jeu de Paume, Paris, October 17, 2017–January 21, 2018

Left:
Albert Renger-Patzsch, *Stapedia variegata. Asclepiadaceae*, 1923
© the artist and Archiv Ann und Jürgen Wilde/ADAGP, Paris

Above:
Arwed Messmer, *Stammheim #12*, 1997/2016
© the artist and courtesy Museum Folkwang, Essen

Arwed Messmer at Museum Folkwang

For *RAF – No Evidence / Kein Beweis*, German photographer Arwed Messmer constructs an exhibition around public photographic material and crime-scene photographs related to the German Autumn, the series of terrorist acts that took place in Germany, in 1977, when the Red Army Faction demanded the release of ten of its members from Stammheim Prison. Messmer's recent works examine the legacy of postwar Germany through archival imagery and reinterpretation: *Reenactment MfS* (2014) is a study of archival images of failed escapes over the Berlin Wall, and *Cell* (2016) compares images of a German politician abducted and held captive in 1975 with the unreleased negatives of a police reenactment of the crime.

Arwed Messmer RAF – No Evidence / Kein Beweis at Museum Folkwang, Essen, June 9–September 3, 2017

David Hockney at the Getty Center

In honor of David Hockney's eightieth birthday, the Getty Center will present an exhibition celebrating the longtime Los Angeles resident, titled *Happy Birthday, David Hockney*, a detailed look at thirteen of his photographs from the 1980s. From 1982 to 1986 Hockney experimented with composite collages. Getty curator Virginia Heckert states that the works attempt to depict sight rather than a decisive moment in a way that was ahead of its time: "This idea of seeing a subject over time and inserting oneself into the process of seeing anticipates digital collaging software."

Happy Birthday, David Hockney at the Getty Center, Los Angeles, June 27–October 15, 2017

Above:
David Hockney, *Sun on the Pool Los Angeles April 13th 1982*. Composite Polaroid
© the artist

international limited-residency
MFA PHOTOGRAPHY

www.hartfordphotomfa.org

Photo © 2017 Kevin Kunstadt

Faculty and Lecturers Include:

Robert Lyons - Director, Michael Vahrenwald, Dr. Jörg Colberg, Alice Rose George, Michael Schäfer, Mary Frey, Susan Lipper, Mark Steinmetz, Ute Mahler, Dru Donovan, John Priola, Alec Soth, Thomas Weski, Felix Hoffman, Lisa Kereszi, Hiroh Kikai, Tod Papageorge

Join us on Facebook:
Hartford Art School – MFA Photo

Alumni Include:

Bryan Schutmaat (USA), Dorothee Deiss (Germany), Felipe Russo (Brazil), Daniel Claus Reuter (Iceland), Matt Eich (USA), Adam J Long (USA), Dagmar Kolatschny (Germany), Leo Goddard (UK), Sebastian Collette (USA), Ward Long (USA), Matthew Casteel (USA), Lucy Helton (UK), Amanda James (USA), Morgan Ashcom (USA), Nicolas Silberfaden (Argentina), Chikara Umihara (Japan)

UNIVERSITY OF HARTFORD
HARTFORD ART SCHOOL
200 Bloomfield Avenue | West Hartford, Connecticut 06117 | USA

Redux
Rediscovered Books and Writings

The history of photography as a worldwide phenomenon
Geoffrey Batchen

At a time when new modes of photographic history are urgently needed, we would do well to revisit the histories written in the 1960s, when a certain freedom of expression was allowed to manifest itself. Of those, perhaps the most remarkable is the one produced by French author Michel François Braive. Published in Belgium as *L'age de la photographie: De Niépce à nos jours* in 1965, it appeared in English in 1966 as *The Era of the Photograph: A Social History*, translated by David Britt and issued by Thames & Hudson in London. There had been "social histories" of photography before it, notably those

written by Gisèle Freund and Robert Taft in the 1930s, but here the phrase seems to encompass a singularly eccentric perspective, given to much rumination and quotations from literature, rather than to an account embedded in economic or political analysis.

The blurb on the inside of the dust jacket points to some of the book's most distinctive features: "Michel F. Braive's choice and arrangement of pictorial material (much of it hitherto unpublished and drawn from his own immense collection) proves not only that a photograph can be a work of art, but

that a picture history can be made into a complex work of art in itself, with an ingenious and often witty 'visual rhythm' of contrasts and comparisons."

Arranged in three parts, with suggestive subsections like "Double and Mask" and "The Coming of Ubiquity," the book features an astonishingly eclectic array of 380 illustrations, including reproductions of postcards, advertisements, caricatures, paintings, drawings, sheet music, prints, ceramics, fashion plates, and a wide selection of photographs. Especially notable throughout the book are the "compositions," shot by a variety of photographers, in which various elements (pictures, photographic instruments, arrangements of book covers, sculptures) have been brought together in conversation.

There are two other striking aspects of Braive's choice of illustrations: many of them are vernacular and self-reflexive, and they have been chosen without any particular national prejudice. In what other history of photography do we find examples of photographs taken in France, Britain, and the United States, but also in Brazil, Vietnam, Tahiti, Russia, Hungary, India, Japan, Egypt, Madagascar, Cambodia, Borneo, Australia, Spain, Indonesia, Denmark, Mali, China, Greece, Canada, Turkey, Congo, and Bolivia, to name only a few of the many places listed in Braive's captions?

This generosity of vision, refreshing in its lack of art historical inhibition, allows the possibility of a history *about* photography, about the experience and practice of photography as a worldwide phenomenon. Seemingly arbitrary in its choices and unapologetically subjective in its tone, *The Era of the Photograph* abandons both objectivity and comprehensiveness, instead inviting its reader to ponder "not only the photographs themselves but also the reactions they provoked." In this, as in its erudite commentary, creative élan, and extraordinary range of interests, Braive's book still offers a model of history-making that deserves our critical consideration.

Geoffrey Batchen teaches the history of photography at Victoria University of Wellington in New Zealand.

Spread from *The Era of the Photograph* (London: Thames & Hudson, 1966)

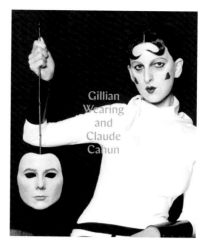

Photography Reinvented
The Collection of Robert E. Meyerhoff and Rheda Becker

Sarah Greenough

In an age when photography can no longer claim documentary veracity as its raison d'être, *Photography Reinvented* examines the medium's redefinition, repurposing, and reimagining.

Cloth $45.00

Published in association with the National Gallery of Art, Washington

Face and Mask
A Double History

Hans Belting

From creations by Van Eyck and August Sander to works by Francis Bacon, Ingmar Bergman, and Chuck Close, *Face and Mask* takes a remarkable look at how, through the centuries, the physical visage has inspired and evaded artistic interpretation.

Cloth $45.00

Gillian Wearing and Claude Cahun
Behind the Mask, Another Mask

Sarah Howgate
With an essay by Dawn Ades and an interview with Gillian Wearing

This beautifully illustrated book draws together for the first time the work of French artist Claude Cahun (1894–1954) and British contemporary artist Gillian Wearing (b. 1963). Although they were born almost a century apart, their work shares similar themes—gender, identity, masquerade, and performance.

Cloth $39.50

Published in association with the National Portrait Gallery, London

Backstory
Irving Penn

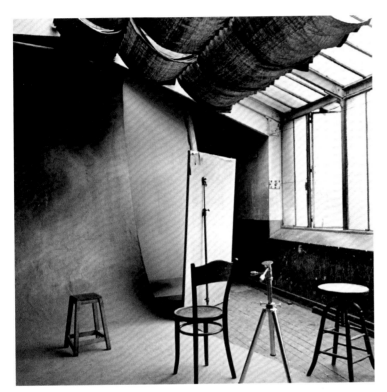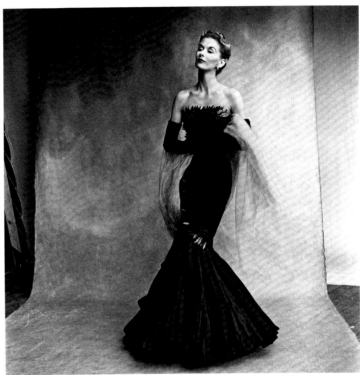

An iconic photographer's backdrop comes to the fore
Maria Morris Hambourg

In the late 1940s, when Irving Penn turned to fashion for *Vogue*, fashion photographers generally shot in an elegant setting—a paneled drawing room with a satin chaise, for example, or a set that simulated the equivalent. Penn had no experience of such rooms, nor of the lives lived in them, and looked for expedient alternatives. He wanted a neutral environment that would enhance the subject without drawing attention, and so he tried various ways to tamp down the specificity of the setting while imbuing it with atmosphere or painterly texture: he posed subjects against mottled stucco walls in Rome, used paper negatives to cast a softening aura, and threw the back wall of his New York studio out of focus.

While preparing to photograph the 1950 collections in Paris, Penn sensed that a theater curtain painted with amorphous tonal clouds—such as those used by Baron de Meyer and his contemporaries for portraits of celebrities at the turn of the century—might be a viable option. He requested a daylight studio and furnished it with just such a curtain. Penn found the curtain's painterly, vaguely airy ambience perfect. The solution was so good, in fact, that it became permanent: the backdrop followed him to London and back to New York, and moved with him throughout his career, serving as the background for the series *Small Trades* (1950–51), countless portraits, and images of fashion.

The curtain created a seamless atmosphere that appeared to underline photography's timeless present. Penn knowingly brought it to the fore, showing its full extent within the surrounding space and thereby making evident the artifice of studio portraiture. The artist's lifelong allegiance to the backdrop is on display in the splendid photographs it helped to create, and additionally in the original object itself.

Maria Morris Hambourg is cocurator, with Jeff Rosenheim, of *Irving Penn: Centennial* at the Metropolitan Museum of Art, April 24–July 30, 2017.

Left: *Irving Penn's Studio in Paris*, 1950; right: *Rochas Mermaid Dress (Lisa Fonssagrives-Penn)*, Paris, 1950
Left: © The Irving Penn Foundation and courtesy the Metropolitan Museum of Art; right: Courtesy Condé Nast

Curriculum
A List of Favorite Anythings
By Leslie Hewitt

Saturated with references to the lives of African Americans, Leslie Hewitt's work explores the poetics of visual history, its absences, and its mysterious narratives. In her series of constructed images *Riffs on Real Time* (2006–9), Hewitt overlaid found snapshots of everyday people onto ephemera, including pages from *Ebony* magazine. Her photographs, often presented in sculptural installations, function as portals into memory, where historic scenes mingle with personal lives.

Eva Hesse: Diaries, 2016

Mon.
Be stronger—say no.
—Eva Hesse, 1964

Each entry from the beautiful object that is *Eva Hesse: Diaries* is a strange yet paralleling space between a finished and unfinished thought. Her objects and drawings in a similar way give room to the viewer, inviting a proximity of intimacy and engagement. How much to reveal and what should remain a mystery (yet to be discovered or experienced) is a delicate balance for all artists. Hesse's interior world (shared in the diaries) is as rich as her material investigations (shared through her studio work).

Pamela M. Lee, *Object to Be Destroyed: The Work of Gordon Matta-Clark,* 1999

In 1990s New York, shifts in demographics were visible, and the effects of public policies shaped my walks through the city. Pamela M. Lee's book on the work of Gordon Matta-Clark—her words contextualize the spatial histories his cuts revealed—was a counterpoint to the modules of erasure that were "cleaning up" the cityscape his art addressed. Lee's writing is crucial to a stance that acknowledges architectural and sculptural acts as sharing a temporal relationship with photography.

David Hammons: Rousing the Rubble, 1991

How can David Hammons's inert objects produce critical energy, curiosity, and a sense of playfulness while evoking complex systems of knowledge and culture? In his mostly nonobjective approach to sculpture, and adept transformation of material, there's a cross-pollination of conceptual art practices with a blues aesthetic. Concepts of introspection and contrapuntal modes of expression evident in the artist's power objects and installations move together seamlessly. Hammons's investigations of objecthood, performance, and provocations guide artists in the twenty-first century toward a formidable critique of systems of power.

Stan Brakhage, *Mothlight,* 1963

The 1960s visually and intellectually provide a place of refuge, even within that era's political volatility and convention-breaking modus operandi. Third Cinema, along with the structural approaches found in the works of Tony Conrad, Michael Snow, and the nonnarrative explorations of Stan Brakhage, give me courage to seek out new visual registers through repetition. Brakhage's *Mothlight* is as arresting when viewing the still frames as it is in motion, asking the viewer to consider collage and montage equally across time and space.

Deborah Willis, *Picturing Us: African American Identity in Photography,* 1996

Deborah Willis's scholarship and mentorship opened a world of criticality and emotion in the approach to photography, challenging me to see beyond the surface of things, to dare to uncover what lay unpictured, underexposed, or overexposed. The juxtaposition of snapshot images with the book's narrative text, built around the pictorial gaps, led me to nestle my artistic practice in a similar space, full of sociopolitical modes, that questions history and asserts agency even in subtle gestures.

Josef Albers, *Interaction of Color,* 1975

Irwin Rubin, a painter and professor at Cooper Union and my teacher, utilized the educational strategies of his teacher—artist and color theorist Josef Albers. In Rubin's course, we interrogated modes of color phenomena and materiality. Beyond the classroom, I could not unsee aspects of color relationships from the moment I opened my eyes in the morning to when I closed them at night. The transmission of art through exchange, methodology, interplay, and experimentation can radically change a person's life.

Sherrie Levine, *Meltdown,* 1989

Sherrie Levine uses appropriation to critique mythologies around art and genius. The results defy categorization and create a symbiotic relationship between her subject of criticism and her artistic gestures. *Meltdown* engages the works of Marcel Duchamp, Ernst Ludwig Kirchner, Piet Mondrian, and Claude Monet, resulting in woodcuts with variations on twelve squares of color. Levine made this portfolio in the late '80s. Considering the velocity of images we contend with by the minute, the contemplative pace of this work continues to mesmerize.

Hito Steyerl, *HOW NOT TO BE SEEN: A Fucking Didactic Educational .MOV File,* 2013

"The most important things want to remain invisible. Love is invisible. War is invisible. Capital is invisible." In *HOW NOT TO BE SEEN,* Hito Steyerl reminds the viewer of the underlying paramilitary technology photographic practices employ, and to what end. This playfully disturbing video creates the cognitive dissonance needed to fully embrace and acknowledge the risks taken while indulging in the virtual window. The socialization process of self-surveillance and constant mediation produces strange effects, procedures, and navigations, one of which is agency.

Project Row Houses, Houston; the Stony Island Arts Bank, Chicago; the Underground Museum, Los Angeles

Writer Greg Tate refers to "maroon spaces" of black music, but could such spaces also exist as architectural sites in the contemporary art world? I would argue yes: At Project Row Houses, where the logic of John Biggers's paintings interacts with the notion of Joseph Beuys's social sculpture and a concrete rebuke of gentrification. At the Stony Island Arts Bank's four dynamic archives (academic glass lantern art history slides, a collection of "negrobilia" or racist "kitsch" objects, house-music pioneer Frankie Knuckles's vinyl collection, Johnson Publishing archive). And at the Underground Museum, with its recent, probing exhibition *Non-fiction.* These vanguard projects create space and open platforms, both in theory and in practice.

Kellie Jones, *EyeMinded: Living and Writing Contemporary Art,* 2011

Genealogy matters in art: Who are your teachers? Your friends? Your community? What are these cacophonies of influences? Plotted onto a graph, is summation even a possibility? Kellie Jones opens up such questions, offering up multiplicity as a system for understanding contemporary art. *EyeMinded* brings to life New York, the creative class, and the intricately laced art worlds that shape Jones's view and her approach to writing about art objects, artists, and the collective act of making meaning.

Opposite, clockwise from top left: Andrea Bowers, *Hope in Hindsight,* October 2009. Photograph by Eric Hester; Barbara Brown, *Eva Hesse,* ca. 1963; Timothy Greenfield-Sanders, *David Hammons,* 1980; still from *HOW NOT TO BE SEEN: A Fucking Didactic Educational .MOV File,* 2013; cover of Josef Albers, *Interaction of Color,* 1975; Gordon Matta-Clark, *Conical Intersect,* 1978; still from *Mothlight,* 1963

Interaction of Color **Josef Albers**

Unabridged text and selected plates
Revised edition

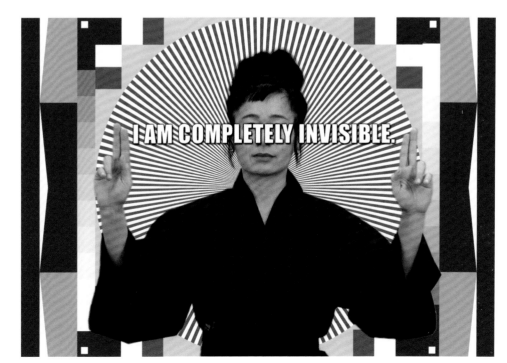

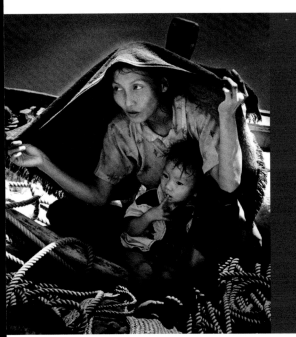

Griffin Editions

WE
MAKE
ART
WORK

**Fine art photographic printing
and mounting for artists,
museums and galleries since 1996**

Dye Sublimation on Aluminum
Silver Gelatin Prints
Chromogenic Prints
LE Silver Gelatin Prints
Pigment Prints
Mounting & Crating
B&W Film Processing
Expert Scanning
Retouching & Color Expertise

Manhattan
390 Broadway

Brooklyn
411 Third Avenue

212.965.1845
griffineditions.com

Dye Sublimation Print in progress. Image © Bruce Gilden.

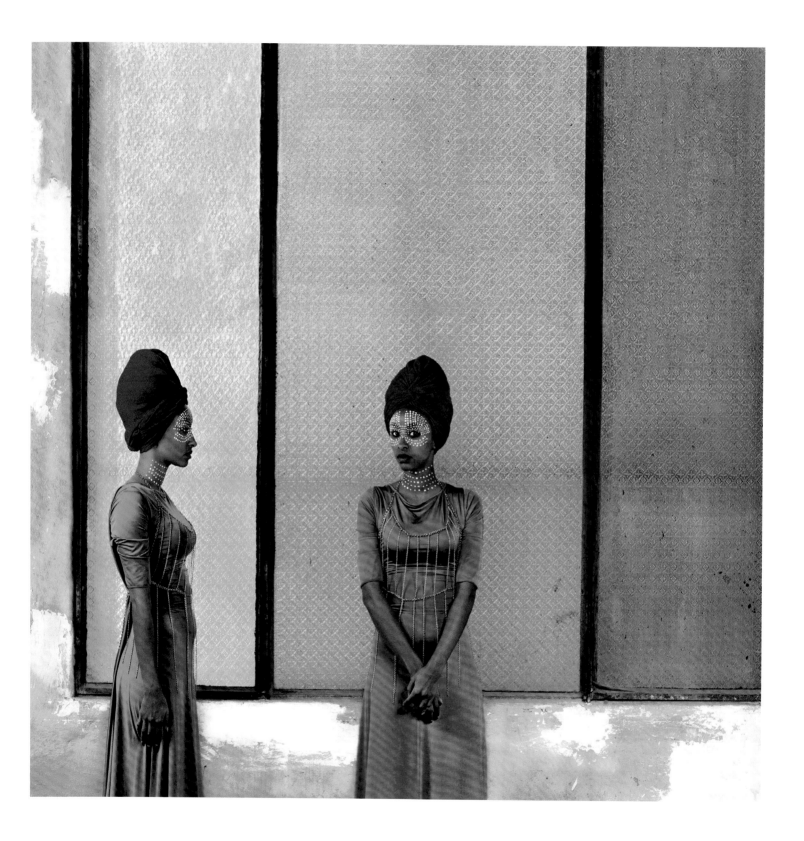

Aida Muluneh,
Local Understanding, **2016**
Courtesy the artist
and David Krut Projects

Platform Africa

"How do we create a meaningful photographic experience on this continent?" the photographer Nii Obodai asked last year at Addis Foto Fest in Addis Ababa, Ethiopia. "We have to map the network." Across this issue, from Johannesburg to Lagos, Dakar to Algiers, the points of connection—schools, workshops, biennials, festivals, project spaces, and artist-led initiatives—form a network of exchanges and dialogues around image-making. While there may be no such thing as "African photography," there is an essential set of platforms for critical engagement with the medium. Three guest editors, working within the sites where artists present their work and build community around photography, have contributed to "Platform Africa": Bisi Silva, founder and artistic director of the Centre for Contemporary Art, Lagos; John Fleetwood, former head of Johannesburg's Market Photo Workshop and current director of Photo:, a new African initiative; and Aïcha Diallo, associate editor of C& (Contemporary And), a magazine focused on contemporary art from African perspectives. Having created their own vital platforms, each is a leader in this dynamic conversation.

New sites build upon older foundations and no platform is more influential, perhaps, than Bamako Encounters: African Biennale of Photography, in Mali, which since 1994 has provided a critical meeting place for photographers and has linked West Africa with practitioners from across the continent and the diaspora. The Biennale continues to exert profound impact. Silva, in her account of its history and evolution, notes that Bamako has recently spurred festivals in Lagos and Lubumbashi. Samuel Fosso, whose stylish investigations of identity have earned him international fame, traveled from the Central African Republic to exhibit his work at the Biennale's inaugural edition. Interviewed as he prepared for a solo exhibition this summer at the National Portrait Gallery, London, he recalled his 1994 encounters with now legendary photographers Seydou Keïta and Malick Sidibé: "Those meetings still frame my career today."

Platforms are also spaces for validation. Profiling the Market Photo Workshop in Johannesburg, Sean O'Toole speaks with recent students of the renowned school, founded by photographer David Goldblatt, which counts among its alumni Sabelo Mlangeni, Thabiso Sekgala, and Zanele Muholi. The workshop, says Muholi, a photographer and LGBT activist, has been "a space to both express and be ourselves." As former students present their photography worldwide, O'Toole observes that they are "connecting disparate geographies." Such desire to span borders defines François-Xavier Gbré's meditations on cultural history in the built environment, in the capitals of Côte d'Ivoire, Senegal, and Togo, as well as in Europe and Israel. Like Gbré, Mimi Cherono Ng'ok is driven by an itinerant impulse, photographing and exhibiting her work around the continent, but privileging poetry of the everyday over geographic specificity.

Mapping new networks means interrogating the power of the colonial past—and the state of the postcolonial present. Malala Andrialavidrazana, a veteran of festivals in Bamako and Addis Ababa, merges historical maps and African currency to provoke cross-cultural associations. Wassim Ghozlani makes "postcards" of anonymous landscapes in contemporary Tunisia. In his overview of new art spaces and photographers in the North African cities of Tangier, Algiers, Rabat, and Marrakech, curator Morad Montazami writes: "The overlap of photography's hyperdistribution with the dizzying sociopolitics of an entire region augurs well for a very wide range of formats and platforms still to be invented." Abdo Shanan and a group of artists in Oran, Algeria, have invented just such a platform. Their Collective 220 is both a support network and a creative laboratory.

Simon Njami, the Paris-based writer and former curator of biennials in Dakar and Bamako, tells his photography students, "It's your gaze first." Two decades after the first Bamako Biennale, the generation of photographers in this issue represents a gleaming vision of contemporary photography in all of its stylistic diversity, its memorable gazes. "We're not talking about 'African' whatever," Njami says. "We're talking about photography." —**The Editors**

Lagos
Khartoum
Dakar
Cairo
Addis Ababa

Five cities where biennials, festivals, and exhibition spaces are changing the shape of contemporary photography

LagosPhoto

There's a character in "Lawless," a short story by the Nigerian author Sefi Atta, who asks, "Who was I to think that art could save anyone in Lagos?" Azu Nwagbogu might have wondered this a decade ago when he founded the African Artists' Foundation, an organization that coordinates the LagosPhoto Festival.

Every year since 2010, Nwagbogu has organized the monthlong festival in Lagos, Nigeria. The photographers invited and the images exhibited are of an international scope, and the approach and attitude is pan-African. The festival's themes are determined yearly by a curatorial team— a "factory of ideas," he calls it—who are joined by guest curators. "It is a platform that relates especially to showcasing a new way of negotiating African contemporary visual history and culture," Nwagbogu says. Through its exhibitions and workshops, the festival's program is designed to be eclectic; while commissioning new work, Nwagbogu and his team also show images by acclaimed photographers that might otherwise go unseen by the local audience.

Spritely, slim, and of Igbo descent, Nwagbogu, who trained as a pharmacist and is known for his natty style, displays an archetypal Lagos energy— that combination of worldliness and street wisdom, the ability to "shine your eye." (To "shine your eye" is to be aware of your surroundings, to defend and offend, to daringly navigate life's traffic jams.) Nwagbogu is inimitably suited for Lagos, and Lagos is an inimitably suitable location for the festival. If Lagos encompasses a larger worldview, that's because of the triple ripple effects of its economy, cosmopolitanism, and cultural influence throughout Africa.

The primary exhibition space for LagosPhoto is Eko Hotels & Suites, a luxury hotel nestled in Victoria Island, the business district once designated as an uninhabitable rubbish dump. Other exhibitions take place in satellite galleries on the island, and outdoors, as large-scale displays in public parks. The festival's program also includes a workshop for younger photographers, many of whom reside in Nigeria. Often mentored by the trio of George Osodi, Kelechi Amadi-Obi, and Akintunde Akinleye, all prominent Nigerian photographers, the participants gain a measure of exposure.

Where the festival has succeeded in riding a wave of African photography's internationalism, the critical apparatus it fosters locally will be the measure of its long-term relevance: LagosPhoto and Hatje Cantz recently copublished *Africa Under the Prism* (2015), a five-hundred-page collection of photographs from the festival. "Perhaps we need to evolve a new language," Nwagbogu says, acknowledging that the concern that impelled him to launch the festival—the need for a less sensational, more nuanced representation of Africa through photography—remains pressing. "We ought to stop worrying about how others perceive us," he says, "but more about how we see ourselves."

LagosPhoto offers a nucleic glimpse of contemporary African photography, yet the scope of the vision is immense. Most of the artists who have emerged from the festival, especially those who have become regular exhibitors, negotiate the familiar with an eye on the conceptual, even the fantastical—as though countering the perverted, realist images of Afro-pessimism requires blurring the distinction between fact and allegory, the real and imagined, the present and future. "There is no endpoint in narrating our own stories," Nwagbogu says. "History is being written in continuum." —**Emmanuel Iduma**

Namsa Leuba, *Untitled I*, **2011, from the series** *Cocktail*
Courtesy the artist and Art Twenty One, Lagos

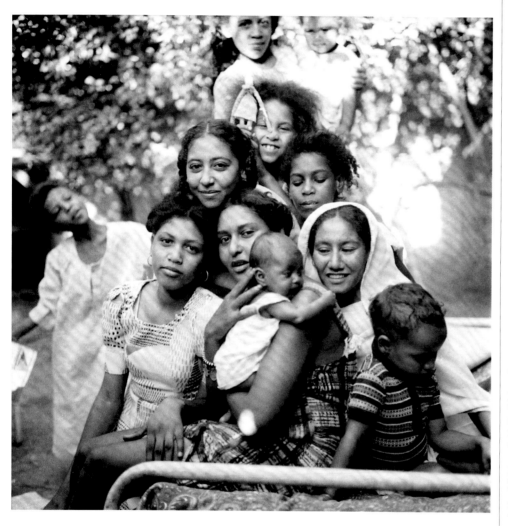

Abbas Habiballa,
The Big Family,
El Obeid, Sudan, 1981
Courtesy Ala Kheir

Sudanese Photographers Group

Alshareef Aboud started shooting pictures after Sudan gained independence from Great Britain in 1956. His medium-format black-and-white images are of crisp urban scenes in Khartoum. There's an image of a zoo in which three boys are feeding giraffes. There's an image of the large Palace Avenue lined with trees, the Grand Mosque of Khartoum backlit in the distance. There's an image of a train stowing into a locomotive shed taken from a bird's-eye view. All of these portray the modernization of the country in progress.

Ala Kheir, a pioneer of the fresh wave of photography in Khartoum, showed these photographs to me recently. Kheir trained as an engineer and

lived in Malaysia before returning to Sudan. He founded the Sudanese Photographers Group (SPG) in Khartoum in early 2007 as a tool to connect Sudanese with an interest in photography. It began when Kheir met Dia Khalil through the photo-sharing website Flickr, and the two hit it off based on their mutual desire to become technically proficient at digital camera work. Together with fellow cofounders Azam Hashim and Mohamed Ginawi, they formed the group.

In the decade since, SPG has gone on to combat the dearth of educational and work opportunities for photographers in Sudan. It has incubated a new group of photographers through workshops, educational film screenings, and portfolio reviews. Alaa Jaffar and Muhammad Salah, to name just two, have emerged from SPG.

While the founders have managed to become technically proficient photographers, Kheir's participation, in 2010, in an Addis Foto Fest master class, which was arranged by the Goethe-Institut Johannesburg and facilitated by curator Bisi Silva, photographer Akinbode Akinbiyi, and former Haus der Kunst director Chris Dercon, added a critical and Africa-conscious aspect to the group's work. "I met people here in Africa who have experience actively photographing Africa," Kheir said. "It was a good introduction to photography as a tool of critical thinking and how we see our space." He later participated in the 2011 Invisible Borders road trip, and his resulting series, *From Khartoum to Addis* (2011), was featured in the 56th Venice Biennale.

Yet these successes point to an earlier golden era of Sudanese photography. As part of an exhibition program in 2014, Kheir visited numerous government archives in Khartoum in search of photographic negatives from the 1970s. He found photographs by Abbas Habiballa in the ministry of information, and he discovered Alshareef Aboud's work through Aboud's son, who attended a workshop with SPG. Kheir's own moody, black-and-white streetscapes of Khartoum, recently exhibited in the 2016 Dak'Art Biennale in Dakar, Senegal, appear to extend Aboud's fascination with the Sudanese capital.

In a bid to expand opportunity and influence, SPG has been registered as a nonprofit in Sudan, partnering with the Goethe-Institut. The Mugran Foto Week, one of their collaborations, was started in 2014 as the final exhibition of a four-week-long workshop; its 2016 edition presented the work of nineteen young Sudanese photographers. By looking to archives and building a platform for new talent, Kheir has created a lineage between new and old photographic practices, empowering a new generation of Sudanese artists to pick up their cameras.

"Sudan is lagging behind in the field of photography, and it is our duty to revive photography and educate ourselves and the public," Kheir said. "I hope that SPG will be the learning hub that will facilitate this knowledge transfer."
—**Serubiri Moses**

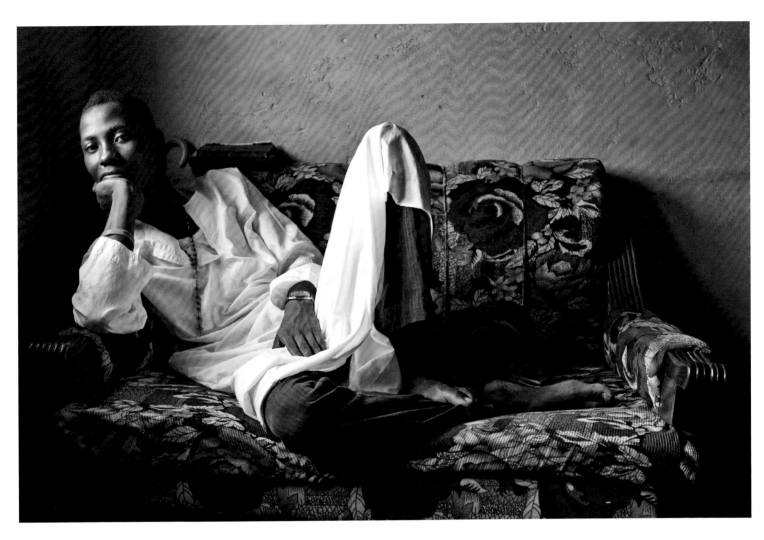

Andrew Esiebo,
Untitled, 2010, from
the series *Who We Are*
Courtesy the artist and
Tiwani Contemporary,
London

RAW Material Company

RAW Material Company is a center for art, knowledge, and society, founded and directed by the internationally renowned independent curator Koyo Kouoh. Although RAW Material Company has existed since 2008, it was only in 2011 that Kouoh decided to open a permanent space, as it had become indispensable for her to have a physical location to ground her activities, as well as to create a place for reflection, debate, and sharing knowledge around contemporary artistic production.

This unique spot in Dakar is composed of two buildings located in a historic area of the Senegalese capital, including a new space that opened last year in a former 1950s residential home of modernist inspiration. Through RAW's Academy and Residency programming for artists and curators, the center invites the development of critical sensibility and the production of ideas. Artist talks, called Vox Artis, and symposia such as *Condition Report* (2012), which focused on the creation of art institutions in Africa, and *Condition Report 2* (2014), which reflected on artistic education in Africa, are organized alongside exhibitions. In addition, since October 2016, Kouoh has begun an experimental residency program for the research and study of artistic and curatorial practice and thought.

It was no coincidence that RAW Material Company opened its doors with a photography exhibition based around George Osodi's work *Oil Rich Niger Delta* (2003–7), which, following an international tour with a stop in Kassel for documenta 12, was shown there for the first time in Senegal. Kouoh, who cocurated the Bamako Biennale in 2001 and 2003, wanted to demonstrate her commitment to promoting this artistic practice that, in her estimation, is "largely ignored in the art schools of West Africa." The exhibition highlighted a selection of ten photographs from *Oil Rich Niger Delta*, accompanied by a slideshow including two hundred other images from Osodi's work. These images reveal the human tragedy and ecological destruction that the Niger Delta and its people are suffering.

Since this inaugural exhibition, RAW Material Company has continued to develop an engaged approach to curatorial practice. Photography has become a vital medium in the projects produced by the center. *Chronicle of a Revolt: Photographs of a Season of Protest*, presented in 2012, was in keeping with this approach. This collective exhibition, which brought together twenty photographers (most of them Senegalese), retraced in images the protests that peppered Senegal in 2011 and culminated in Macky Sall's victory in the presidential elections on March 25, 2012. For Kouoh, "These photos translate Senegal's commitment to democracy, social dialogue, and stability, combined with a strong desire for leadership change and respect for constitutional law."

Another exhibition in which images played an important role was *Precarious Imaging: Visibility Surrounding African Queerness* (2014). This show, curated by Kouoh and Ato Malinda, interrogated the visibility of LGBT individuals in Africa, where homosexuality is illegal in thirty-eight of fifty-four countries, through the works of Kader Attia, Andrew Esiebo, Zanele Muholi, Amanda Kerdahi M., and Jim Chuchu. *Precarious Imaging* was the second act of a program dedicated to individual freedoms, with an emphasis on the rise of homophobia in African societies. The highly controversial exhibition, which was prematurely closed following protests by conservative religious groups, was originally presented as part of the 2014 Dak'Art Biennale OFF, a series of exhibitions throughout Senegal supported by the Biennale's main program in Dakar.

Art often goes hand in hand with activism at RAW Material Company. As Kouoh says, "Creativity is an indispensable tool for political and social transformation."
—**Carole Diop**

Translated from the French by Matthew Brauer.

Contemporary Image Collective

To reach the premises of Cairo's Contemporary Image Collective (CIC) is an exercise in negotiating the very constitution of the city. There is the arrival to downtown by way of any one of the bridges that serve like veins over the Nile River and across the miles of growing urban sprawl: the chaotic, overpopulated so-called city victorious, whose residents have come to claim what space they can around tentacles of unplanned roads and a pandemonium of traffic. There is the organism of downtown itself, with its pedestrian streets and sidewalk vendors and rows and rows of shoe shops that seem to operate, in their multitude, on a supply-demand logic of their own. And there are the people, in decadent colors, who occupy sidewalk and street space alike, hand in hand, strolling, browsing, eating, hustling.

This cacophony of life, efficient as it is in its apparent disorder, is the introduction to CIC, which was founded in 2004 by a group of practicing artists and photographers "to develop and nurture visual culture and artistic practice, engagement, and discourse in Egypt," through workshops, exhibitions, a photography school, and various other programs. Situated in a grand old dilapidated building in the heart of downtown, the programming, conversations, and exhibitions of the collective capture both the energy of the city and its particularities of constitution. Numerous exhibitions have also spilled out of the main CIC premises and into spaces across downtown.

This sanctuary of creativity has been at once witness and instigator. Over the years, I've attended a couple of workshops and many talks, and I have even had to hustle for a standing spot as audience numbers reached capacity and overflowed into the building's stairwell. In some ways, much has changed for the collective as its reputation and those of its founders (including the artists Maha Maamoun and Rana El Nemr) have grown internationally; its current, and sixth, iteration of PhotoCairo, *Shadows of the Imperceptible*, which takes place across various venues downtown, is by far its most dynamic, and boldest. In others, CIC has remained untouched at the core of what it was founded to do. It plays host to one of the few reputable photography schools that exist in the country, and despite all the challenges of fundraising and stamina in a postrevolutionary Egypt, it continues to provide a place of possibility. "CIC is different," said the artist Nadia Mounier, who exhibited her work in PhotoCairo6. "For me, it goes beyond producing photo work and is more about the philosophy behind making photos."

As Maamoun told me, "Thirteen years down the road, we remain susceptible to the elements—the precarious life of arts and culture institutions in general—which requires a lot of malleability. I actually feel we are at our youngest ever; the energy, sensitivity, and thoughtfulness of our particularly gifted team have transformed CIC's internal organizational thinking as well as its programming. Both are more vulnerable, reflective, and responsive to the needs and concerns generated by the contexts we live and work in."

On any given day, there is a sense inside CIC of a nuanced, thought-provoking snapshot, a space for interpretation and consideration, of the outside.

—**Yasmine El Rashidi**

Maha Maamoun,
***Untitled (Parrot),* 2015**
Courtesy the artist and
Gypsum Gallery, Cairo

Sarah Waiswa,
Seeking to Belong, 2016,
from the series *Stranger
in a Familiar Land*
Courtesy the artist

Addis Foto Fest

"When someone tells me something is impossible," Aida Muluneh said earlier this year, "I'll do it anyway."

Last December, Muluneh stood at a podium outside the ballroom of the palatial Sheraton Addis Ababa, where she inaugurated the fourth edition of the Addis Foto Fest. Among the crowds were government ministers, corporate leaders, and many of the 126 photographers, from forty countries, whose work was displayed in an exhibition behind the ballroom's grand entrance. Striding up the red carpet, they all pressed closer to the doors before Muluneh officially opened the show.

Muluneh, an Ethiopian, Addis Ababa–based photographer and founder, in 2010, of the Addis Foto Fest, has long pressed for alternative representations of Ethiopians. As a child, she lived in Yemen and England before her family settled in Canada. She took photography classes in high school—borrowing a teacher's Pentax—and opened her first exhibition at the age of nineteen. Muluneh's mother often told her stories of Ethiopia, but her descriptions of the homeland were at odds with the images of the Ethiopian famine widely published in the 1980s.

"Most Ethiopians are tired of seeing all these negative images," Muluneh told me. "But, like any household, there are always multiple stories to one family, and it's the same for a nation."

After studying film at Howard University in Washington, D.C., she joined the *Washington Post* as a photojournalist. She also pursued fine art photography. When she submitted her work to the 2007 Bamako Biennale, where she won the European Union Prize, she told the curator Simon Njami she wanted to start a festival in Ethiopia. But in Addis, the capital of the African Union and a city vibrating with the noise of Chinese-funded construction projects, photographers are often confined to working in the commercial sectors. Seeking to establish a platform for photographers to tell original, authentic stories, Muluneh envisioned a photographic community built on education and connected internationally.

"I didn't want to do an 'African' festival," she said. "The important thing is cultural exchange through images. It's a learning opportunity, not just for Ethiopian photographers to see foreign photographers' images, but also for foreign photographers to come here and see what photography looks like in Africa, in the Middle East, in Asia."

At the center of the 2016 exhibition were groups of framed prints by Ethiopian photographers, many of whom regularly participate in workshops with DESTA for Africa (DFA), the arts consulting firm Muluneh established in 2010 to support the Addis Foto Fest. Together, in their street scenes or chronicles of religious ceremonies, they demonstrate an earnest desire to portray Ethiopian culture—in particular Aron Simeneh, a twenty-one-year-old photographer from Addis, who made a series of studio portraits of elderly military veterans.

"A lot of young photographers see this as their duty," Muluneh said of the Ethiopians she has worked with through the festival and mentored at DFA.

Hailing from elsewhere on the continent, Ugandan photographer Sarah Waiswa documented an albino woman dreamily wandering through Nairobi, while Francis Kokoroko, the Ghanaian behind the popular Instagram handle @accraphoto, showed enigmatic portraits and landscapes that appeared like stills from an experimental film.

On the last day of the festival, Muluneh convened a conference with an international group of artists and curators. Nii Obodai, a photographer based in Ghana, where he organizes photography classes through his platform Nuku Studio, spoke about the need for African photographers to connect with each other on their own terms.

"How do we create a meaningful photographic experience on this continent?" Obodai asked. "We have to map the network."
—**Brendan Wattenberg**

Bamako Revisited

In Africa's capital of photography, the influence
of an essential biennial

Bisi Silva

In 1998, I traveled to Bamako for the first time to attend the third edition of Bamako Encounters: African Biennale of Photography. At the time, I was an independent curator based in London, and was thus humbled and refreshed to learn that a space existed on the continent for presenting the work of photographers of African descent—many of whom had yet to gain recognition in the West. Since that eye-opening experience, I've followed the evolution of the Bamako Biennale, the longest running platform for photography in Africa, by attending nearly every subsequent edition in various capacities—as a spectator, presenter, curator, and, most recently, in 2015, as the artistic director for the tenth edition.

Titled *Telling Time*, this edition marked a milestone in the Biennale's history on a number of levels. Not only was it celebrating the tenth anniversary of the event, but *Telling Time* also heralded the Biennale's return after a four-year period of absence due to the political instability and threats to Mali's sovereignty brought about by the jihadist insurgency of 2012. This confluence of political upheaval and cultural expression dates back to the very conception of the event. Mali's first democratically elected president, Alpha Oumar Konare, staunchly supported the Biennale's founding in 1994, envisioning it as an opportunity to test the capacity of culture to rehabilitate the nation's image and restore international confidence following decades of violent authoritarian rule under Moussa Traore. For the tenth edition, local stakeholders renewed their investments in the power of culture by once again positioning the Biennale as a tool for strengthening Mali's fragile democracy and increasing its international visibility.

I view my role in the tenth edition as part of the efforts to reinvigorate the local, insofar as the responsibilities granted to me marked the first time in the Biennale's history that a curator based in the region (in 2007 I founded the Centre for Contemporary Art in Lagos) was chosen as the artistic director. Intimately familiar with the Biennale's history and evolution, I accepted the challenge of devising an expansive program that would honor the event's influence, question its place and relevance to current lens-based practices and discourses in Africa, and proffer possibilities for the Biennale's future. This multiplicity of perspectives animated the

conception and execution of the tenth edition's focus on questions of time and of the local.

The coexistence of different temporalities is a defining characteristic of Bamakois urbanism. Bamako is a place where the past unavoidably engenders a symbiotic meeting with the present, a place where tradition and heritage are at one with modernity. From these perspectives, I consider Bamako a "city village" where tall modern buildings rise in close proximity to modest residential dwellings of neotraditional design, and modern cars mingle, at times, with animal-driven carts. While these characteristics make Bamako an ideal site for discursive exhibition platforms, it should be noted that Mali is one of the least economically prosperous countries in the region. On first sight it lacks the infrastructure to host international art happenings: there exist no degree-granting educational establishments providing photography courses at any level; there is virtually no collector base; and there are no major art-publishing initiatives, to name a few enabling prerequisites.

But Mali has a deep cultural past with a long and strategic history. By the fourteenth century, the University of Sankore in Timbuktu had established Mali as an internationally renowned site for Islamic study, with ancient manuscript traditions dating back to the eleventh century. It is the land of the griots and the country of the Dogon people, and of the fourteenth-century magnificent mud mosque in Djenne. Its empires and its emperors, such as Sundiata Keita and Mansa Kankan Musa, are legendary. Malians today remain fiercely proud as well as protective of this cultural heritage. Even in the absence of purpose-built contemporary art venues in Bamako, the Biennale benefits from adequate venues like the Palais de la Culture, the main site of the Biennale before its transition to the National Museum of Mali; the Musée du District de Bamako; the Modibo Keita Memorial Centre; and smaller informal spaces around the city. With this structure, it is no surprise that Bamako would stake a claim as the "capital of photography" on the continent, a status that endures but that may be undermined by increasingly inadequate official support.

The Bamako Biennale started in 1994—founded by French photographers Françoise Huguier and Bernard Descamps—two years after the Dak'Art Biennale in Senegal positioned itself as a forum dedicated to contemporary art. Both can be considered the result of the proliferation of mega-exhibitions and biennials that were springing up in so-called margin locations around the world in the 1980s and 1990s. But most importantly, these two events were responding to the absence of platforms for African artists within and outside of the continent, and to the visibility of the growing number of artists working in Africa and the diaspora. They provided important meeting points for artists, curators, writers, editors, and other art professionals to meet, interact, and exchange.

Consequently, the Bamako Biennale, through its focus on photography, has directly and indirectly spurred a plethora of lens-based platforms and smaller initiatives across the continent. One of the earliest, though short-lived, was the Rencontres du Sud (Southern Encounters), started by Ivorian photographer Ananias Léki Dago in 2000. Other events included Rencontres Picha, in Lubumbashi, Democratic Republic of the Congo, started by Congolese artist Sammy Baloji in 2008; Addis Foto Fest, founded by Ethiopian photographer Aida Muluneh in 2010; and LagosPhoto, developed by Nigerian cultural entrepreneur Azu Nwagbogu, also in 2010. These events have been supplemented by new artist collectives such as Invisible Borders, a pan-African collective of photographers and writers who travel by road across Africa, as well as new educational programs and workshops that have manifested across the continent in the past decade.

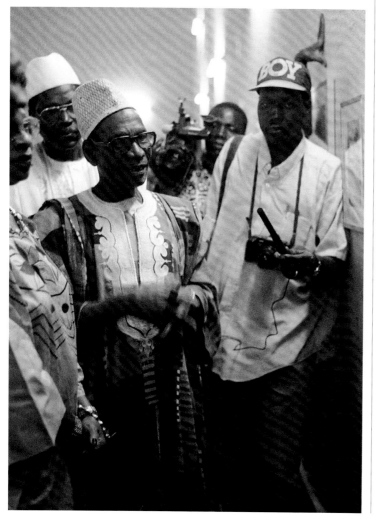

Youcef Krache,
Untitled, March 13,
2015
Courtesy the artist
and Collective 220

Bamako is a place where the past unavoidably engenders a symbiotic meeting with the present.

Unlike the major biennials, which often become instruments of governmental politics, the foregoing artist-led initiatives are grassroots organizations that have been cultivated from the ground up, providing training and professional development—in the absence of appropriate education initiatives—with exhibition-making. In addition, they impose no geographical limitations to participation, arguing that international or transnational integration takes cognizance of global parameters.

Despite the profusion of platforms in Africa, which are poised to continue, it becomes necessary to question whose interests are ultimately served through the development of these initiatives, and how, if at all, they harness local infrastructural growth with international visibility. When the Bamako Biennale began, it had a local premise. It symbolized the nation's embrace of democracy and was supported by President Konare, who understood the role culture could play after the end of a prolonged dictatorship. However, there were tensions from the beginning as to what a French-Malian partnership might look like. From the outset, France played an integral role in the production of the Biennale. Although Mali is now more involved in management decisions, the French have been criticized for their neocolonial relationship regarding the event. Nevertheless, the original aims, which sought to foster collaborations and develop the embryonic field of African photography, as well as the local scene, have seen tremendous success.

There have been many local beneficiaries of the Biennale, some more successful than others. In the early editions, Seydou Keïta and Malick Sidibé, already with burgeoning international careers, were catapulted into foreign museums, galleries, and collections. In 1994, the Malian government announced its intention to found the Maison Africaine de la Photographie— finally created in 2004—to strengthen the presentation and

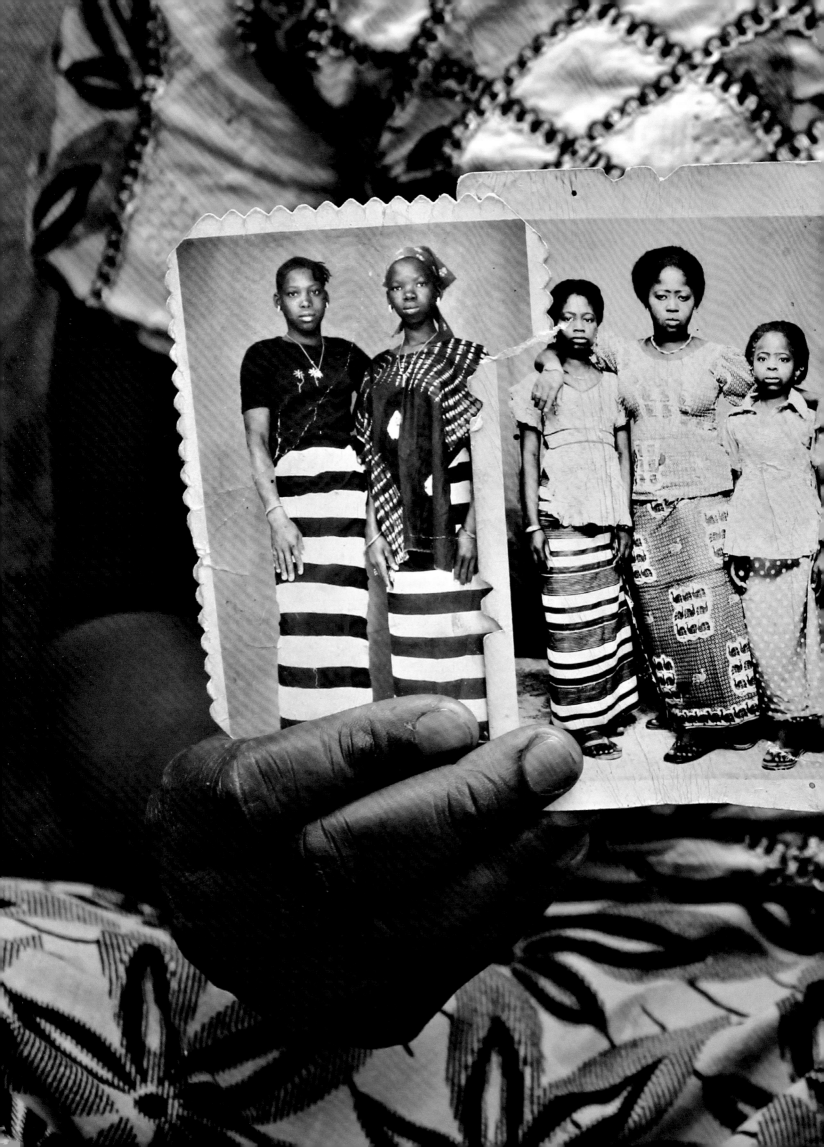

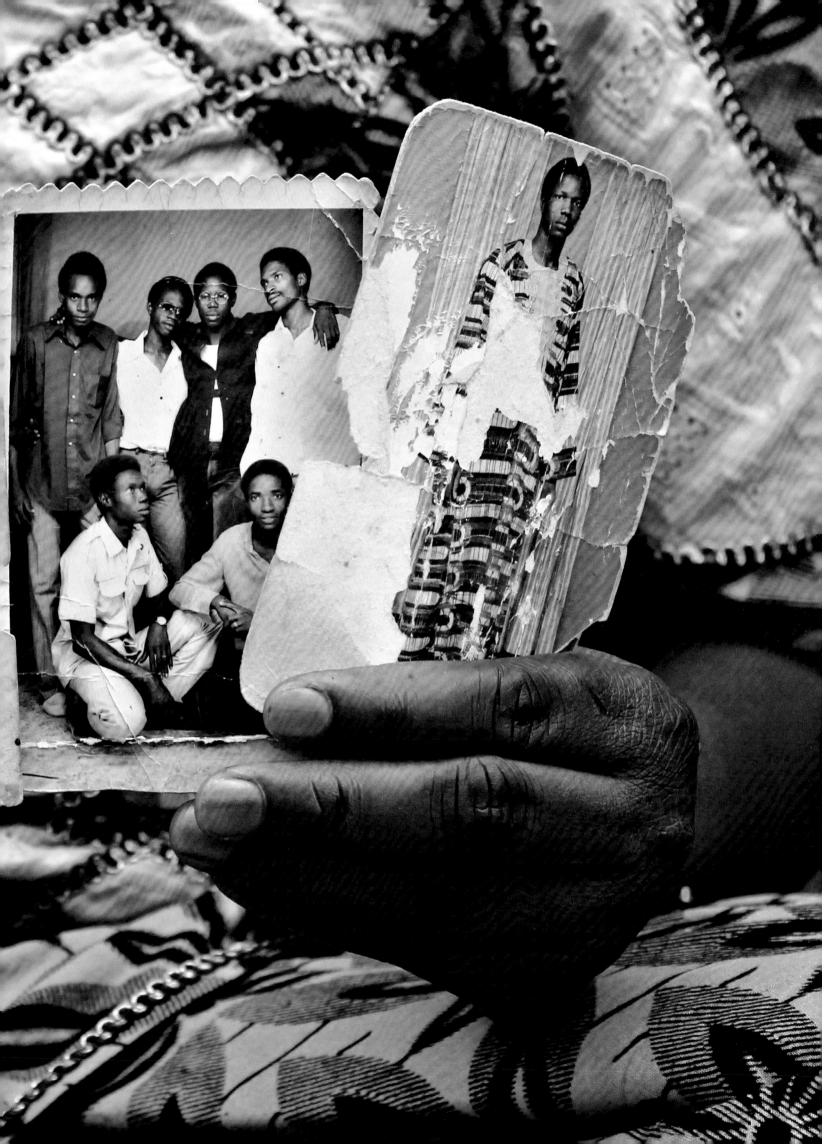

The Bamako Biennale has directly and indirectly spurred a plethora of lens-based platforms and smaller initiatives across the continent.

dissemination of photography across Mali and neighboring countries. Education centers, especially the Cadre de Promotion pour la Formation en Photographie (CFP), established in 1998 and generously funded by Helvetas Mali, produced a new generation of photographers. Promo-femme: Center for Audio Visual Education for Young Women was created in 1996 to develop and nurture the first generation of women photographers, including Fatoumata Diabate, Amsatou Diallo, Alimata Traore, and Penda Diakite (who opened her own studio in 2002, considered the first by a woman in Mali). Over the course of its existence, numerous women were trained and some participated in the Biennale, such as Diabate, who won the Afrique en Création prize during the 2005 edition and has since gone on to develop her career internationally.

While Keïta and Sidibé were accepted and acknowledged as national treasures at home who catalyzed the developing Malian art photography scene, their celebrity status—due to important group exhibitions such as *Africa Explores*, curated by Susan Vogel in New York in 1991, and Keïta's 1994 solo exhibition at Fondation Cartier in Paris, for example—has contributed inadvertently to the eclipse of equally important and impressive Malian studio photographers including Adama Kouyate, Mountaga Dembele, Abdourahmane Sakaly, and Tijani Sitou, among others. Unfortunately, it also has had repercussions for the next generation of photographers, such as Racine Keita, Mamadou Konate, Emmanuel Bakary Daou, Alioune Bâ, and Youssouf Sogodogo, who all have been creating important bodies of work since the 1980s. Although some of this photo-based work was shown during the first or second editions of the Biennale, these photographers have not been able to sustain interest in their work once it fell outside the genre of studio photography, which continues to govern associations and expectations for photography in Mali.

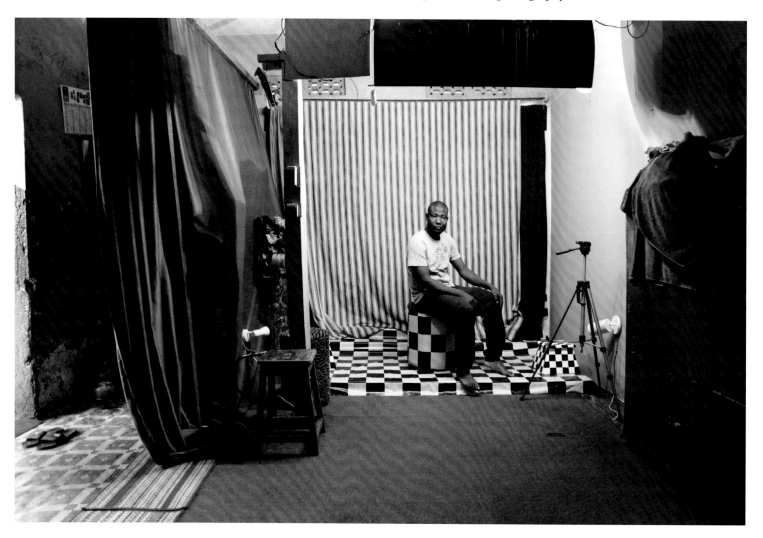

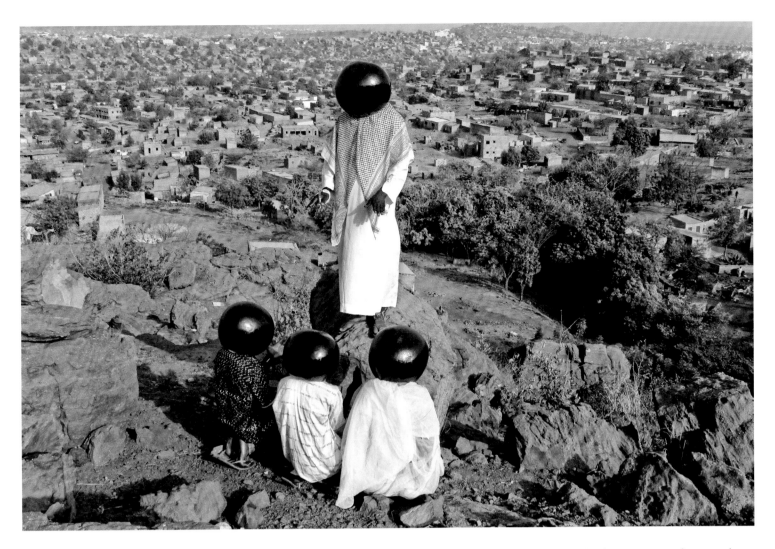

By the third edition in 1998, when the event began to take on a more international outlook, the possibilities for inclusiveness became limited, with the participation of Malian artists becoming overshadowed by the scale of the Biennale and the broader inclusion of international artists. Some of the early attempts at consolidating the local sector were short-lived, despite a period of increased funding. With the appointment of Paris-based, Cameroonian curator Simon Njami to head the next four editions, from 2001 to 2007, the international status of the Biennale was confirmed, and so too was the consolidated influence of the French government on the event.

Not dissimilar to the climate in which the Biennale was founded two decades ago, *Telling Time* developed during a period of optimism after the fall of a dictatorship and a four-year hiatus due to insurgency. The tenth edition provided an opportunity to look back in order to move forward. It was obvious that neither the country as a whole, nor the Biennale as a single, though crucial, entity, could continue without tangible integration with, and benefits to, the local population. The key question for the tenth edition was how to deviate from abstract pronouncements of local engagement and develop concrete programs within the Biennale that were locally conceived—in essence, how to make the Biennale a local event with international visibility.

This approach was reflected in *Telling Time*, which I conceived in collaboration with two associate curators, Antawan I. Byrd and Yves Chatap. The edition's substantial Focus Mali program was instituted through a rigorous consultative process. It was an attempt to kick-start the long journey back "home." As director general Samuel Sidibé signals in the Biennale publication's introduction: "The local engagement is one of the major pillars on which this edition was constructed." Focus Mali included an exhibition of work by a new generation of Malian photographers organized by Malian curator Amadou Chab Touré; an invitation to twenty photography studios across all the boroughs of the capital to collaborate on presenting their archives in mini-exhibitions that were co-organized by Malian journalist and cultural producer Amadou Sow; and an ambitious educational workshop that involved sixty-four schools, reaching approximately five thousand students. The local and the international, pedagogical and scholarly, historical and contemporary coalesced in the tenth Biennale and also in its expansive publication, which was itself conceived to be a dynamic platform under the art and editorial direction of Byrd.

Questions of sustainability naturally circumscribed the development of the Biennale, as they do in most places. Like the Dak'Art Biennale, the Bamako Biennale suffers from the grip of government departments at home and abroad. But one aspect that brings a sparkle of hope is the growing visibility and dynamism of the event's large and growing OFF program, initiated by local artists. Malian photographers are increasingly overcoming the limitations of local professional development and education initiatives by traveling in Africa and abroad for residencies. The path to cultural self-determination and articulation is visible with locally driven projects, including Emmanuel Bakary Daou and Patrick Ertel's Espace Photo Partagé and its monthly Bamako Samedi Photo; the dynamic Medina Gallery, founded by social and cultural entrepreneur Lassana Igo Diarra; and Photo Kalo, the Month of Photography, started modestly in 2016—all of which might provide needed, year-round activities to position Bamako as a hub of cultural activity beyond the Biennale. Only time will tell.

Bisi Silva is the founder and artistic director of the Centre for Contemporary Art, Lagos.

Through the Lens

In Bamako, a group of young photographers
engage a changing city

Franziska Jenni

Bamako, the capital of Mali, is situated along both sides of the Niger River and figures as a dynamic trade hub where diverse cultural and social influences converge. Due to an ongoing rural exodus in Mali, Bamako is one of the continent's fastest growing urban areas. Like other African cities, it can be described as a complex configuration, in which the "postcolonial condition" manifests itself and is constantly renegotiated in various social, political, and cultural formations. Within this context, artists play an active role, consciously mirroring and questioning the places where they live. Emerging photographers are engaged with the city of Bamako, presenting contemporary outlooks on the urban environment and the experiences within it. Amsatou Diallo, Mamadou Sekou Kone, Oumou Traore, Aboubacar Traore, Seydou Camara, and Fatoumata Diabate, all in their thirties, not only depict Bamako, but also chronicle urban life, offering critical understandings of how young people see themselves, their city, and their connection to the wider world.

While Seydou Keïta, Malick Sidibé, and Abdourahmane Sakaly, to name just a few of the vanguards of Malian photography, became famous for their commissioned black-and-white studio portraits and reportages at festivities in Bamako, their successors diversified their approaches to photography: Mamadou Konate, Emmanuel Dao, and Racine Keita, who all trained in studio photography, began leaving the studio to use photography in more abstract or photojournalistic ways. Alioune Bâ and Youssouf Sogodogo, on the other hand, worked at the national museum, and their photographic practices were also influenced by a sense of cultural documentation. Today, many photographers have been trained by the Cadre de Promotion pour la Formation en Photographie (CFP). Most of these photographers no longer work in studios, but are active as freelancers, earning their livings by shooting marriages and baptisms, as did their predecessors, or taking pictures for NGOs. Yet, many also maintain independent work that often blurs the boundaries between art and documentary photography, creating new and personal visual vocabularies.

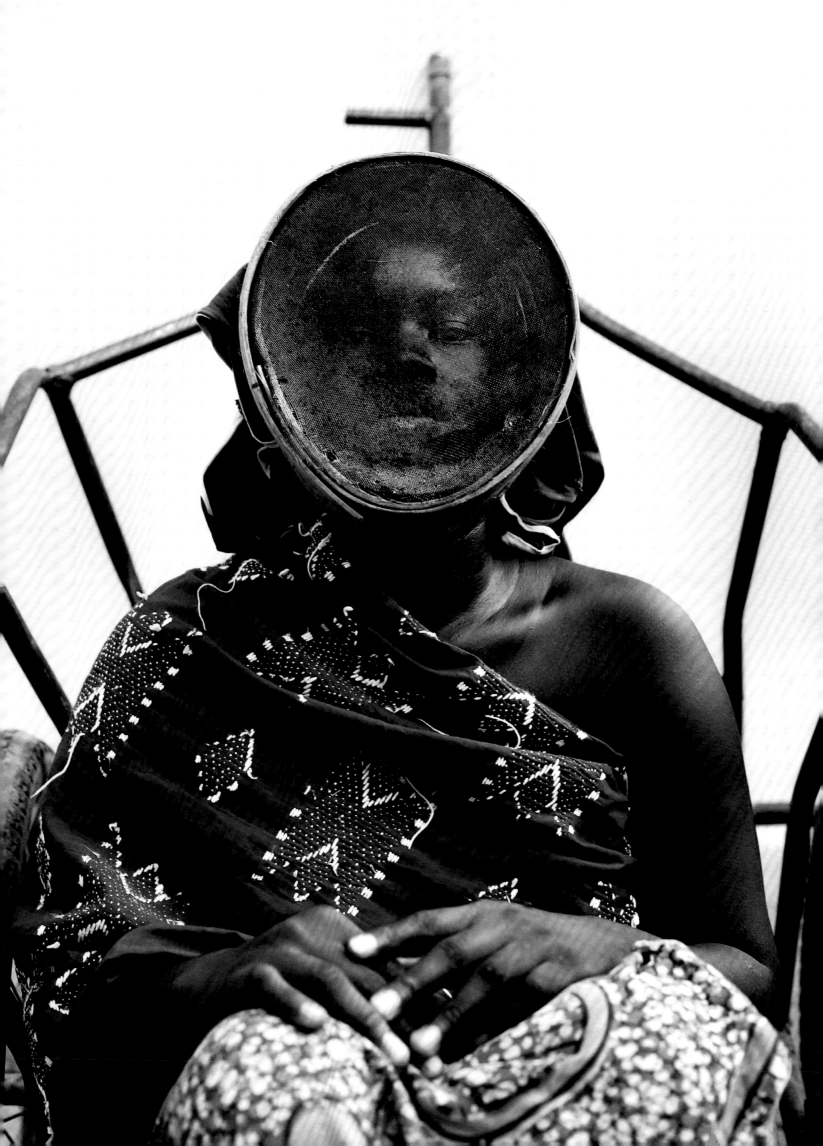

In the series *Bamako—des fenêtres du Sotrama* (Bamako—windows of Sotrama, 2016), Amsatou Diallo circulated for days in Sotramas, popular minivans, through the streets of Bamako. These vehicles are the city's most frequently used means of transportation, allowing the majority of citizens to participate in broader city life. Through the differently shaped windows of the Sotramas, Diallo immortalized hundreds of small scenes of unspectacular urban life from the outskirts of Bamako to the city center: an elderly woman crossing the street, a small mosque with its speakers attached to the minaret, posters of the last elections hanging on a pole. By framing public urban space through these windows, Diallo highlights and celebrates scenes from everyday life. Many practices repeat themselves in small variations throughout a day. By doing so, they bring ordinary city life into being. The assembled incidental scenes suddenly reveal a bigger picture of the city.

While Diallo's photographs explore Bamako during the daytime, Mamadou Sekou Kone's *Le silence de la ville* (The silence of the city, 2016) explores Bamako by motorcycle late at night. His photographs reveal another side of the city, seen without its inhabitants, when citizens have withdrawn into private places and the public space presents itself as quiet, stark, and empty. Electric light reduces the view, bringing more static elements of the urban space to the fore: streets, bridges, and traffic signs emerge sharply under the streetlights; illuminated billboards, huge trees, and monuments loom out of the darkness. The black-and-white photographs are reminiscent of film stills. Their apparent timelessness dignifies the city, and, in the dreamlike state of night, boundaries and shapes blur, presenting a sense of placelessness.

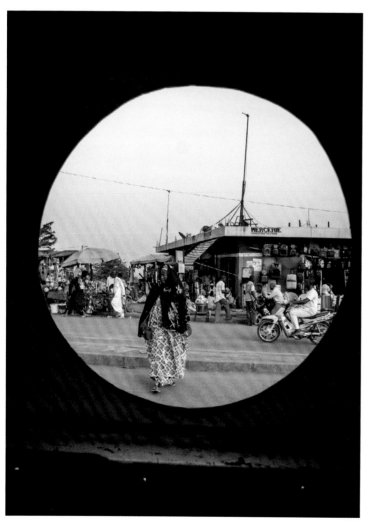

Highlighting an individual, personal level of experience in the city, Oumou Traore's series *Deux soeurs à Bamako* (Two sisters in Bamako, 2016) focuses on the lives of two sisters who emigrated from the Dogon country to the capital to work as domestic servants. This subject resonates with Traore's own immigrant experience of working as a servant to earn money to pay for her basic expenses, and the costs necessary for becoming a photographer. Her intimate portrayals of the lives of the two new arrivals unfold, from the inside and the private to the outside and the public. She follows the sisters from dawn to dusk, sensitively capturing the labor-intensive routine of the two domestic workers and highlighting the invisible roles they play in Bamako's city life.

In the last few years, the unprecedented growth of Bamako has brought with it highly questionable practices of urban land management, where the powerful and rich often win out over the poor. Aboubacar Traore is a constant observer of the city's evolving landscape. Between 2009 and 2014, for his series *La porte de l'enfer* (The gates of hell), he documented the demolition of houses and the expulsion of their inhabitants. In one image, the remnants of a family's house can be seen days after its destruction, executed by goons who were acting under police supervision. Most of the family members had left to find temporary shelter with relatives. Traore's photographs show an unsettling discrepancy between the destroyed infrastructure and the effort of three remaining sons who continue everyday life in the ruins, not giving up on their rights. The series reveals how some citizens in Bamako cope with constant uncertainty, where from one day to another everything can change and usually does.

As a participant in the Photographers' Master Class, initiated by the Goethe-Institut Johannesburg and curator Simon Njami, Seydou Camara traveled to Khartoum, Sudan, in 2016. The class provided him with the opportunity to reactivate his long-term project *Les Soufis* (The Sufis), started in 2012, which looks at Sufi practices and how they are performed across Africa. Camara's work delivers a careful and nuanced picture of Islam, with emphasis on the religion's peaceful aspects. During his stay in Khartoum, he photographed dervishes who gathered at a cemetery to pray

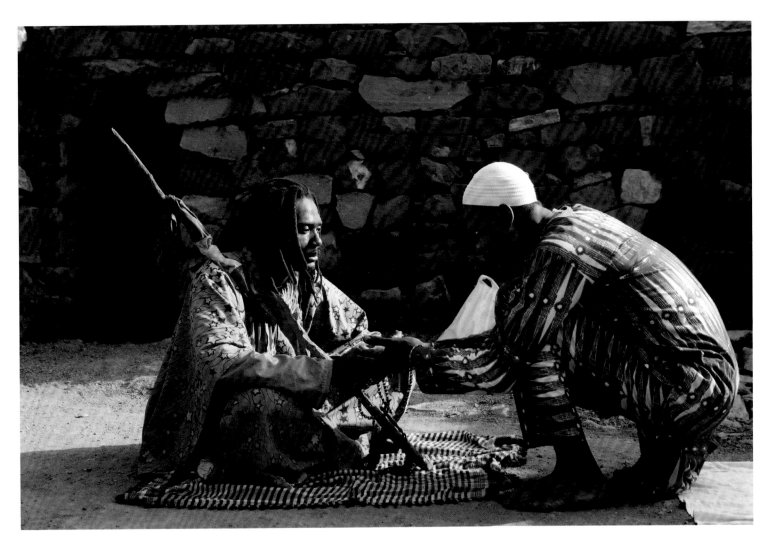

Seydou Camara,
*One of the sons of the
late El Hadji Soufi Adama
Yalcouye receives a
worshiper in their mosque,
which was built in the
midst of the Niger's
riverbed*, 2016
Courtesy the artist

Camara's work delivers a careful and nuanced picture of Islam, with emphasis on the religion's peaceful aspects.

for their sheikh. Back in Bamako, Camara turned his lens toward Malian practices of Sufism, portraying the everyday lives of the followers of the late El Hadji Soufi Adama Yalcouye. Adama did not belong to an established Sufi brotherhood; rather, he practiced a fusion of Islam, Christianity, Dogon, and Bamana religious beliefs. Camara's pictures illustrate the diversity, complexity, and liveliness of Sufism in Africa.

Mali's famous studio tradition, however, continues to influence younger generations. In her project *Studio Photo de la Rue* (Studio photo from the street, 2013–ongoing), Fatoumata Diabate reenacts the famous Malian photography studios of the 1950s and '60s. Inspired by the works of her Malian predecessors, including Seydou Keïta, Malick Sidibé, and Youssouf Sogodogo, but also the Cameroonian, Central African Republic–based artist Samuel Fosso, Diabate created a mobile studio, which she has installed in Bamako, as well as in the French cities of Arles and Montpellier. Clients entering this nostalgic studio are encouraged to choose props and clothes, pose in front of a textile backdrop, and spontaneously slip into other identities. The studio is a stage-like, open-air installation where the whole process becomes a performance. The final portraits create something of a playful time lag: Diabate's twenty-first-century clients enter her small time machine, which transports them back to the golden age of studio photography in Bamako.

Franziska Jenni is a PhD candidate in the Department of Social Anthropology at the University of Basel.

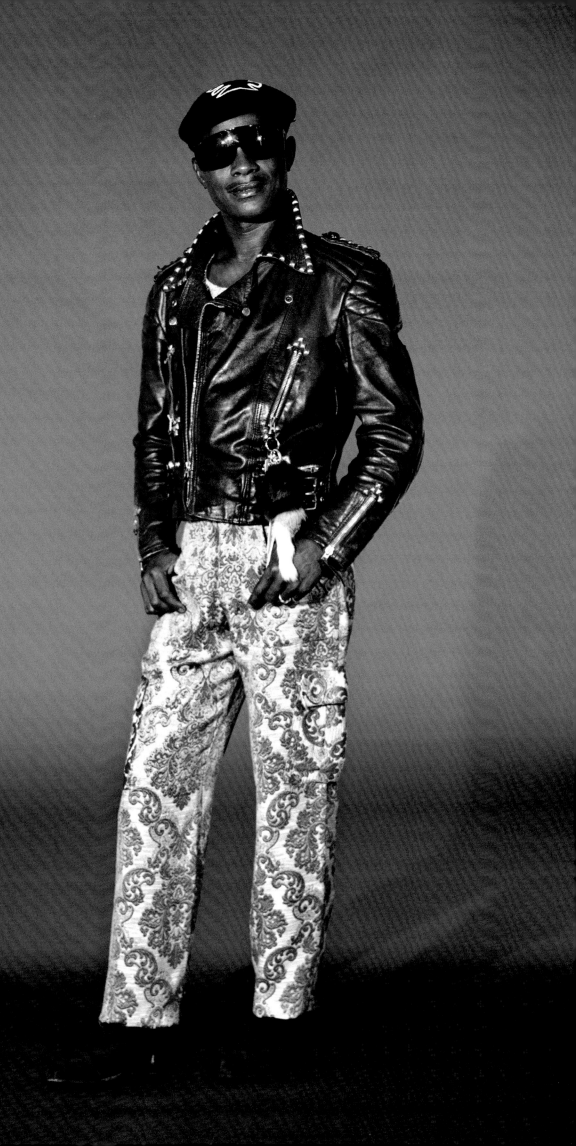

The Lives of Samuel Fosso

A Conversation with Yves Chatap

It all began with the high heels. In 1976, as a precocious teenager, Samuel Fosso traveled from Bangui, Central African Republic, where he operated his own photography business called Studio Photo Gentil, to visit his family in Nigeria. There he discovered a pair of platform boots similar to those worn by the popular Nigerian highlife musician Prince Nico Mbarga on the cover of his record albums. Fosso's grandmother agreed to buy him the boots, and upon returning to Bangui he completed the look, ordering a pair of bell-bottoms from a local tailor. "I put on my new outfit and went out. In the street, I ran into a priest who said, 'You look handsome. You look like an astronaut. Do you want to reach heaven?' And I answered, 'Yes!'"

For more than forty years, Fosso, like Cindy Sherman, Iké Udé, and Yasumasa Morimura, has focused on one subject: himself. In the 1970s, after making pictures for clients, he would finish off rolls of film by staging imaginative self-portraits, wearing sunglasses, bathing suits, and fashions that would have challenged the conservative sensibilities of '70s-era Bangui. By playing with the cultural codes of style and pose, Fosso evoked the power of personal transformation. His early experimental images remained private until 1994, when he was invited to participate in the first edition of the Bamako Biennale. Since then, often using a team of stylists, Fosso has pushed his self-portraiture into new realms of gender-bending theatricality.

Ahead of his solo exhibition at London's National Portrait Gallery in June 2017, Fosso spoke with Paris-based curator Yves Chatap about studio photography, artistic influences, and taking on the roles of a lifetime.

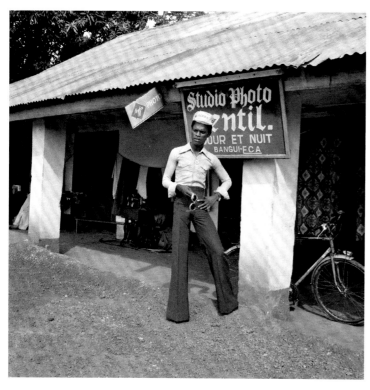

Self-Portrait, 1976–77

I started taking pictures of myself to make up for the absence of photography in my childhood.

Yves Chatap: Your earliest exhibition dates back to the first Bamako Biennale in 1994. Can you tell us about that experience?

Samuel Fosso: For the first edition of the Biennale, emissaries were sent all over Africa to find photographers. There was a French photographer, Bernard Descamps, who discovered my work while visiting Bangui and invited me to participate in this exhibition. When we met, I was already working in color, but Descamps wanted to see my black-and-white images from the 1970s, which he then submitted to the jury. That's how I got my first show at the Palais de la Culture in Bamako, which was inaugurated by then president of Mali, Alpha Oumar Konare.

During my stay in Bamako, we did workshops. Six months later, I learned that I had won first prize, which I was awarded in September 1995 in Paris, where I went for the first time. It was then that I had my first exhibition in Paris, with Martin Parr and Marie-Paule Nègre.

YC: How did this first visit to Europe go?

SF: It gave me the chance to meet photographers like Henri Cartier-Bresson, who congratulated me and advised me about my work. I didn't know him, but that encouraged me to carry on, as did the support of Malick Sidibé and Seydou Keïta, because I came to understand that my process was an asset that I shouldn't overlook.

YC: When did you become aware of the work of other African photographers?

SF: Before coming to Bamako, I didn't know any other African photographers like Malick Sidibé or Seydou Keïta, but they seemed to have known my work, because my photographs were hung before I arrived. I have to admit, I didn't know I was making artistic photographs. It was a discovery for me. It was a big surprise to have Malick Sidibé and Seydou Keïta coming to give me advice on my work and to encourage me about my future as an artist-photographer, explaining that it was rare to see a photographer photograph himself. I thanked them for their advice and encouragement and was able to get to know their works during the exhibition.

All of that opened my eyes. Once I got back to Bangui, I continued working, because I said to myself, If I don't produce anything, they will forget about me. Those meetings still frame my career today.

YC: Let's go back to the beginning. How did you get started in photography?

SF: I was born in Cameroon. As a child, I suffered from paralysis, and my mother was too ashamed to have my picture taken like other babies. I was cured under my grandfather's care in eastern Nigeria, but then war broke out in Biafra in 1967. It was then that my uncle brought me first to Cameroon, then to the Central African Republic, where we worked making women's shoes. On our street, there was a studio photographer who I began to spend time with. I asked him to teach me photography. I spent five months as an apprentice, after which I wanted to have my own studio. The problem was making prints without wasting too much paper because, as my uncle said, "You don't do business for loss, you do business for gain." But I found out that the owner didn't want me to leave because he had stopped losing money when I started working in his studio. After learning that, my uncle told me to find a space for my own studio and he bought me an enlarger.

YC: You mentioned your childhood and your illness. Isn't your self-staging today a form of therapy for that suffering body?

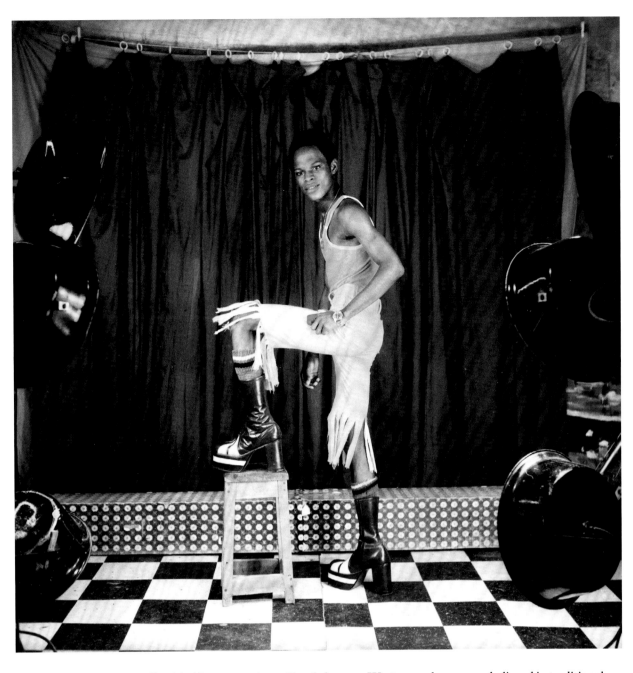

SF: It is indeed, because body movement is part of health, if you think about athletes, for example. For my body, it was the distress of illness and healing, but also the cure that my grandfather worked on me—perhaps I had to suffer from that. When you look at my work, it's my body that is looking at me. It's my way of seeing. Perhaps it's my illness. I don't know. But what matters is that it is my natural body.

YC: **Do you see your grandfather as a hero?**

SF: For me, yes, my grandfather is a hero because I am not the only person he had to heal. He was a healer his whole life and he took care of the mentally infirm. Whenever anyone brought an insane person to my grandfather, after two weeks the person would begin to respond and to recover their natural state and normal consciousness. Then, the family could come take them back. At that time, money was hard to come by, so people paid him in hundredths of a shilling. My family couldn't really make ends meet. He healed many people. The whole village considered him a hero. He was an important figure who the village asked for advice on major decisions. For me, he's a hero, and he is deserving of the term.

YC: **Why put this personal history into images?**

SF: Simply because Westerners have never believed in traditional medicine. I bear witness to the idea that the healer can treat many things. It's a way of educating about the practices of traditional medicine that have long been rejected.

YC: **What was the motivation behind your first self-portraits in the 1970s?**

SF: I opened my own studio on September 14, 1975. I started taking pictures of myself to make up for the absence of photography in my childhood. I used the last frames on rolls of film because I didn't want to waste them. When I closed the studio for the day, I would take pictures of myself and send the images to my grandmother in Nigeria. I had clothing custom-made based on things I saw in magazines, mostly Afro-American ones.

YC: **Your inspirations in adventurous fashion can be seen in your first images in the 1970s. Did you have icons in mind when you made those photographs?**

SF: If you take the example of Nico Mbarga—I was mostly inspired by him, especially by his outfits. I had clothing made, and I bought shoes called *talons dames* that you couldn't find in central Africa. As for Fela Kuti, it was political because there were denunciations.

Top:
La Bourgeoise, 1997,
from the series *Tati*

Bottom:
*La femme libérée
américaine dans les
années 70* (The liberated
American woman
of the 1970s), 1997,
from the series *Tati*

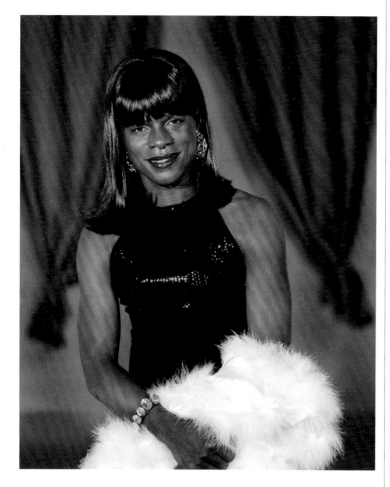

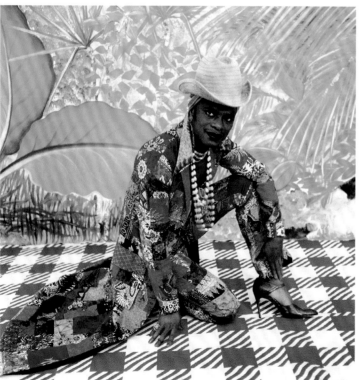

We still weren't free, and so we couldn't just do whatever we wanted. From 1977 to 1980, and especially before democracy, conditions weren't easy, particularly because of the political denunciations. That scared me because I didn't want to get arrested.

YC: **So, you were aware that your approach could have political consequences?**

SF: I was aware that there were political consequences and, as a result, I couldn't just do whatever I wanted.

YC: **Three years after you participated in the Bamako Biennale, you were commissioned by the Paris department store Tati to make a series of images.** *Tati* **(1997) contains some of the most famous images of your career. It's about archetypes and characters, from the rock star to the businessman to the bourgeois woman. In this series, what message did you want to deliver?**

SF: It's a discourse about segregation and slavery and a demand for independence and freedom. I gathered all these ideas together, as you can see in the image *La femme libérée américaine dans les années 70* (The liberated American woman of the 1970s), which I made before my first visit to the United States, and in the series *African Spirits* (2008), which follows the same path. In *African Spirits*, there is a desire to inscribe within the museum space all those figures who have marked the history of blacks in Africa and in America. It should be known that they all fought for civil rights and liberties for blacks. This is a heritage that we must not forget. I had to pay homage to them because they have allowed us to be free, in a way, and to give them their place in history so that our children may remember what has happened in the past and what is still happening today.

YC: **Your series** *Mémoire d'un ami* **(Memory of a friend, 2000), about a neighbor in Bangui who was burglarized and killed, and** *Le rêve de mon grand-père* **(My grandfather's dream, 2003), about your grandfather, are highly personal explorations. When you work with your body, do you experience it as a subject body or an object body?**

SF: When I work, it's always a performance that I choose to undertake. It's not a subject or an object; it's one more human being. I link my body to this figure, because I want to translate its history. I consider my body as a human being, but always belonging to other subjects, to the person who I am in the process of reproducing.

YC: **And, technically, how do you work in the studio?**

SF: I work with a team consisting of costumers, makeup artists, and an assistant photographer to carry out my shoots. Before, as I said, I did photography without realizing that I was an artist. I created my self-portraits on my own with an eight-to-ten-second delay timer. Now my work is easier, since I use a remote-controlled camera, which lets me see if my pose matches the image that I want. It's an advantage over the past, because the technique is the same but the shot is different in relation to the work.

YC: **You returned to Bamako in 2007 for a retrospective of your work. What were your impressions of that experience since the first Biennale? In particular, what was your relationship with the young photographers who saw you as** *le grand maître* **(the great master)?**

When I work, it's always a performance that I choose to undertake. I link my body to this figure, because I want to translate its history.

SF: By 2007, things had developed very quickly, and this retrospective was important because I had changed since 1994. I had produced other works in keeping with the earlier series, so returning to Bamako in 2007 for a solo exhibition was a point of pride. I met many Malian photographers who wanted to meet me and talk about photography. They called me "the great master." And the BBC had produced a documentary film about me in 2002. We discussed photography and the way that I made my images. This solo exhibition that began in Bamako toured all over the world for the next two years thanks to the French Ministry of Culture. My impressions of the young photographers were overall positive because they understood the importance of African photography. That left a strong impression on me because I knew that African photography would not die.

Yves Chatap is an independent curator
based in Paris.

Translated from the French by Matthew
Brauer.

YC: In 2013, you made the series *Emperor of Africa*, in which you performed as Mao. The images were based on famous paintings of the Chinese leader. Why did you make this series?

SF: After enslavement by the West, there was colonization, then political independence, which is absolutely not economic independence and still besets us today. We find ourselves with China profiting from our lack of means without providing sufficient financing in return.

In Africa, no one realized what China would become on the continent. Every African country has been seized by China. I see what they've made of their own country with the production of coal and pollution. They came here with a fifty-fifty proposal to rebuild Africa, on the pretext that Europe no longer has the means to do so. Now, you see that they are destroying and looting the continent's natural resources for their own interest, Africa having been unable to develop its own means of local production. But if China went away, what would Africa become without its money? That's where the title *emperor* comes from, in view of the history of that country that has only ever lived under an imperial system.

YC: When you talk about relations between Africa and Asia, is there not a kind of fatality about the future of Africa, and also of the individual?

SF: This series translates the observation of a form of repetition of history around questions of autonomy and the exploitation of resources. We cannot accept the implantation of the Chinese empire in Africa out of fear of reproducing the past. Among African states, relations are complicated and agreements difficult, so if we ourselves can't manage to find common ground, nothing will change.

YC: In your latest series, *SIXSIXSIX* (2015), the body is no longer in costume. The artist is without makeup. Why did you choose to orient yourself in this direction?

SF: This series collects 666 images in total, each of which is unique. It's a work where photographic material has nothing to do with analog prints. The challenge was to make 666 different self-portraits with a different bodily expression in each.

In this series, there is unhappiness and happiness, misfortune and good fortune. I was very inspired by these two aspects. *SIXSIXSIX* refers to the number of misfortune. By that I mean in terms of what I've encountered in my life up to now. After my illness came the Biafra war; millions of people died, and I was fortunate to be saved. I went to the Central African Republic where I experienced the same thing during the conflicts of 2014, in which I could have died. So, 666 is a number of misfortune and at the same time is a number of good fortune. For all that I've been through, God has been with me and has saved me.

YC: In *SIXSIXSIX*, do we see Samuel Fosso or someone else?

SF: It's neither the body that smiles, nor the body that cries, but a representation of life and all the misfortunes that strike us deep within. In the end, it's about buried emotions that we ourselves create, and about exorcising my own resentment in the face of this situation. From 1976 to 2014, I have never been at peace in my life when faced with the actions of those who always sow misfortune among children and innocents.

SCHOOL

DAYS

Inside the Market Photo Workshop
Sean O'Toole

"I really could use a break right now!" Phumzile Khanyile said in February. The Soweto-born photographer was slumped on the step of a ladder, supervising the installation of *Plastic Crowns*, her exhibition of self-portraits, which, in twenty-four hours, would inaugurate the new premises of Johannesburg's Market Photo Workshop. Earlier this year, the school of photography founded in 1989 on gut intuition and an activist impulse by David Goldblatt— a stoic chronicler of everyday life under apartheid and the transformations that have reshaped South African society since the first democratic elections in 1994—relocated from its former home in a cramped, retrofitted post office to its current location on the eastern side of Mary Fitzgerald Square. Jodi Bieber, a documentary photographer who started her career there in the early 1990s after picking up a flyer for the school and seeing her way out of an unhappy marketing job, described the new, four-story building as a "palace."

I asked Khanyile, who wore a majestic red wig crowned with a black cap, if she felt daunted by the prospect that her show would launch the much-lauded school's new gallery space. "I try not to think about it because it will get me all worked up!" Two years ago Khanyile won the Gisèle Wulfsohn Mentorship in Photography and worked with Ayana V. Jackson, an itinerant American photographer who shares her interest in self-portraiture and exploring identity through role-play, to produce a new body of work. The domestic-scale identity politics of *Plastic Crowns*, while very Instagram, slot into a category of postdocumentary practice introduced by earlier workshop graduates, notably Nontsikelelo "Lolo" Veleko, best known for her affirmative portraits of friends claiming the streets of Johannesburg in hipster dress, and Musa N. Nxumalo, whom Khanyile assisted in 2014. But her work also tracks more widely. Her photographs, which were mounted in clusters on a red-painted wall and complemented

Thabiso Sekgala,
Jane Nkuna, Loding,
former KwaNdebele,
2009
Courtesy the Estate
of Thabiso Sekgala and
the Goodman Gallery,
Johannesburg

by mirrors bought at flea markets, recall the awkwardness of Francesca Woodman's frail self-imaging and the commodity fetishism of Guy Bourdin and Ellen von Unwerth.

"It is fresh work," remarked Paballo Lekalakala, a graduate of the workshop who has pursued a dual career in freelance news and event photography, as he helped Khanyile install her show; although, he conceded, "I'm not sure what it is about." Khanyile knows. "That's my mom's favorite," she said in reference to a photograph showing her leg against a white curtain. In the image, she is wearing a red shoe, which belongs to her mother. The shoe yields a metaphor. Last year she rationalized her interest in self-portraiture to a reporter from the local *Sunday Times*: "It's like being in somebody's shoes; that is what makes me understand what I'm doing. And there's nothing I find more intimidating than my camera. It stares at me and shows all my flaws."

If there is something commonplace about this scene, particularly within its ritual of youthful self-expression channeled through commodity culture, consider the context. Born in 1991, a year after the white-minority government unbanned thirty-three political organizations and released their leadership from jail, Khanyile is about as old as South Africa's democracy. She was a child when Themba Hadebe, a workshop student between 1991 and 1994, clinched a World Press Photo Award for his compelling 1998 portrayal of a street hustler cornered by his gun-toting victim in an alley in central Johannesburg. She was only an adolescent in 2003 when Zanele Muholi, now internationally renowned for her ambitious chronicle of black queer life in South Africa, completed her advanced studies at the workshop.

"South Africa has changed," John Fleetwood said, stating the obvious. But Fleetwood, who took classes at the workshop in the early 1990s and later returned to run the school from 2002 to 2015, knows that the self-evident often requires explanation. The arc of the workshop's visual output has expanded from an early focus on social documentary photography to more expressive, conceptual, and self-oriented or community-focused work, such as Muholi's expansive portrait archive, Nxumalo's insider views of Soweto's tattooed punk-rock scene, Lebohang Kganye's sculptural photo collages and performative self-portraits, and, most recently, Khanyile's photograph of herself wearing her mother's red shoe. The documentary idiom, however, endures, as is evident in Jabulani Dhlamini's *uMama* (2012–13), a portrait series of working-class single moms and their children, produced during a professional mentorship with Bieber, and Sipho Gongxeka's *Skeem' Saka* (2014), an examination of black masculine identities, made with Pieter Hugo serving as his mentor.

The workshop's output offers an up-close view of a society undergoing change, yet still marked by widespread unemployment and the persistence of black poverty. "There has been a shift in the circumstances of black South Africans over the years," Fleetwood said. "This extends to the current students, who are now closer to middle class." Class, though, is a privilege, not a guarantee of visual literacy. Along with social transformation, which is gradually shifting entrenched privileges away from the minority white population, technology has also changed the parameters of what entry-level students now know and understand as photography. "Early on, people were shy and uncertain about photographing themselves," Fleetwood recalled; when assigned self-portraits they would photograph their rooms, their houses, their streets, all surrogates of the self. "The new generation arriving here already has a thousand selfies. Modesty is gone." Modesty, but also the dilemma of always being viewed as a totality, as a sociological group, be it poor or black, or both.

David Goldblatt welcomed the new and assertive photography that began to emerge in the early 2000s. He was fascinated by the

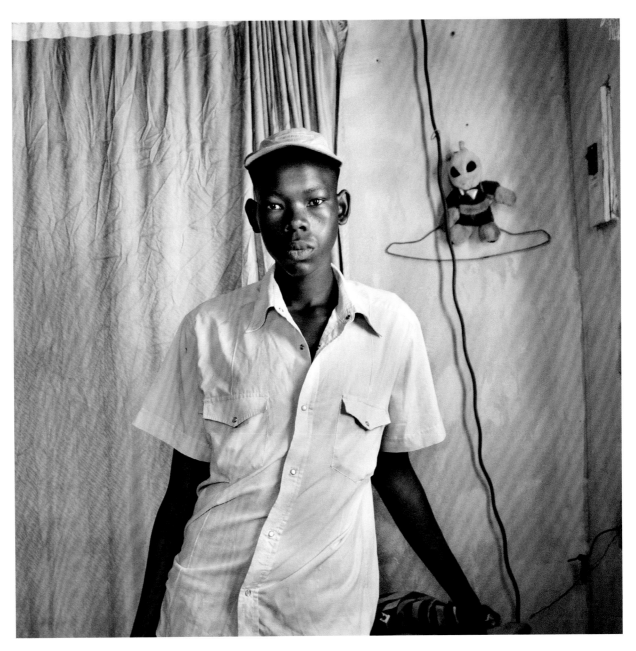

"daringness" of Veleko's vibrant color street portraits. Goldblatt is particularly close to Muholi. After studying at the workshop, she told him, "You're going to mentor me." She praised his "generosity," "open-mindedness," and "willingness to listen." Muholi, who often speaks using a plural pronoun, added: "We are really indebted to him for giving us a space to both express and be ourselves. Some of us grew up without fathers, and he filled that role for me."

Goldblatt also spoke warmly of later workshop graduates, notably Sabelo Mlangeni, whom he has been assisting with compiling his archive of postapartheid Johannesburg, mostly street scenes, and Thabiso Sekgala, a promising young talent who committed suicide in 2014. Sekgala's portraits from his breakout series *Homeland* (2009–11) anatomized the unequal achievements of democracy through a tight focus on rural youth and places where democracy's gains have been uneven. "His work is magnificent," Goldblatt said. Born in Soweto, in 1981, Sekgala was raised by his grandmother in the nominally independent "homeland" settlement of KwaNdebele, around the time Goldblatt was traveling back and forth with black bus riders for his book *The Transported of KwaNdebele* (1989). In 2010, Sekgala was awarded a Tierney Fellowship, a prestigious early-career prize that includes professional mentoring. He worked with Magnum photographer Mikhael Subotzky. "We were friends who came from different worlds, yet we had so much in common," Subotzky told me in 2014.

The arc of the workshop's visual output has expanded from social documentary photography to more expressive, conceptual, and self-oriented work.

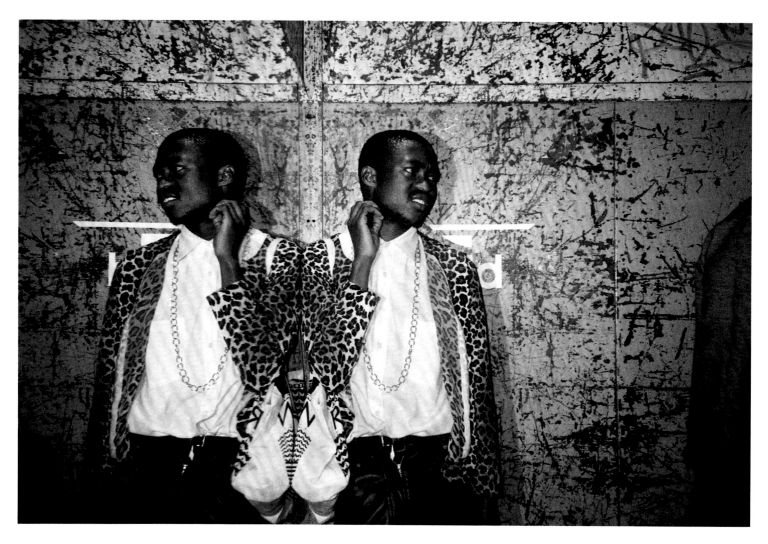

Although closely linked to the workshop, Goldblatt was never a hands-on teacher. "I wasn't a frequent visitor. I went in two or three times in a month, and then not for another month or two. There would be prints on the wall. I can't tell you how exciting and rewarding that was. Here were people who frequently had no sense of the so-called arts, and they were doing amazing work." Goldblatt was referring to the unbalanced distribution of art and design training at state-run high schools, particularly in still-segregated black neighborhoods or townships. This basic lack, which endures into the present, is what prompted Goldblatt to establish the workshop in the first place.

The beginnings of the workshop are generally pegged at 1989, but in Goldblatt's telling the story starts a decade earlier. In 1976—the year of the Soweto Rebellion, a galvanizing event in resistance against white-minority rule that was courageously photographed by Peter Magubane—producer Mannie Manim and playwright Barney Simon opened the Market Theatre in a disused market hall in Johannesburg's Newtown district. It quickly gained a reputation as a progressive space with a dissident voice. Goldblatt curated a photography exhibition for the launch of the theater. "We invaded private albums. From that developed the idea of showing work that was off the beaten track. We had quite a few forward- and backward-thinking exhibitions in the 1970s." This ad hoc approach eventually culminated in a little gallery wedged into an awkward corner space. Despite its "no budget" formula, the gallery staged shows by Chris Killip, Mike Disfarmer, Ansel Adams, and Alfred Eisenstaedt. It was a way of working that the future workshop would inherit.

"In 1985, I noticed that more and more black people were coming to look at our exhibitions," Goldblatt said. "It was a very noticeable phenomenon, particularly among young people. Being somewhat antediluvian, it took me a few years to wake up." Working with art critic Joyce Ozynski, whose credentials included a stint editing the literary journal *Snarl*, they approached various funders with the idea of offering photography classes pitched to black audiences—but open to all races—at the Market Theatre. To fund them, Jeremy Ractliffe, the father of photographer Jo Ractliffe, secured ten thousand dollars in start-up capital from the DG Murray Trust. "I'm full of ideas, but not very good at the execution of a lot of them," said Goldblatt. "I thought vaguely we would muddle through, which is exactly, in fact, what happened."

The photographer Gillian Cargill was hired as a teacher. When details of her course were advertised in a local newspaper, the overwhelming response of white enthusiasts, who had the option of studying at racially segregated universities and technical colleges, prompted a quick rethink. Fees were "recalibrated," with underprivileged students—predominantly black applicants—offered scholarships. The nonracial entry criteria, however, remained. The earliest night classes ran over three months on weeknights and were presented in improvised settings, mainly rehearsal rooms. Hustle is a key reason for the workshop's endurance. Goldblatt and his coterie of well-meaning white liberals eventually managed to secure the workshop a home in a disused post office, with its apartheid architecture intact. One of the first gestures of occupation involved boarding up the white and nonwhite entrances.

Today, a prospective student at the workshop can apply to enter either the foundation or intermediate course, both of which are three months in duration, or can pursue the yearlong advanced courses, which are split between media witnessing and authorship photography. The latter course, Lekgetho Makola, the current head of school, explains, is "for people who want to see their work in gallery spaces." The fees, while high given the modest family circumstances of many students, represent only half the total cost

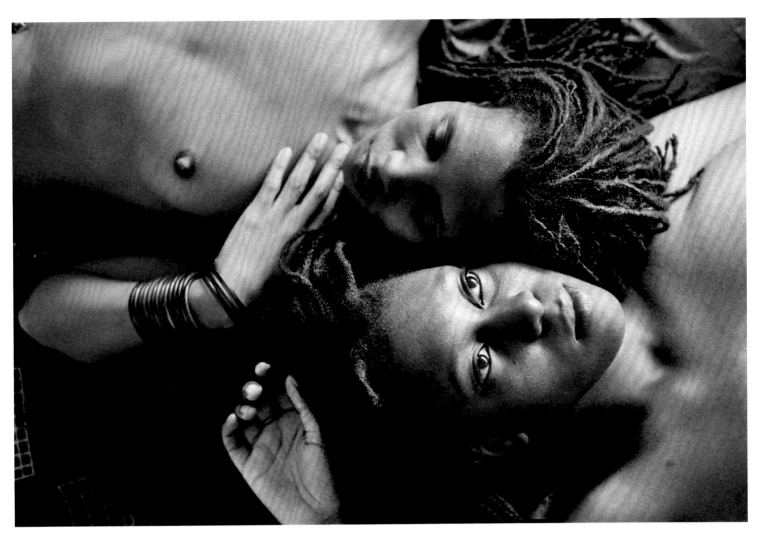

Opposite:
Musa N. Nxumalo,
Thato "Santu"
Ramaisa, 2015
© the artist and courtesy
SMAC Gallery, Cape Town

This page:
Zanele Muholi,
Beloved IV, 2005
© the artist and courtesy
Stevenson, Cape Town
and Johannesburg

Apartheid sought to create a black underclass denied of any imaginative agency. Imagination, therefore, is necessarily subversive.

of tuition. The workshop is still heavily reliant on donor funding. Since 2005, the Market Theatre Foundation—of which the Market Photo Workshop is a division—has been administered by the national government's Department of Arts and Culture, an arrangement that rankles Goldblatt, a vigorous champion of free expression, although he admits it is necessary for the workshop's survival.

Designated as a cultural facility, the workshop resembles a functioning photography school in all other respects: it has classrooms, digital and analog labs, an exhibition gallery, and a functioning library. One of the reasons the workshop is so esteemed is its curriculum, which Goldblatt played a key role in instituting. "There are moral and ethical questions that arise in the making and using of photographs," he wrote in 2002, "and I think we would be failing if we did not give students an awareness of them and so lead them to question the values that they bring to their photography." It remains an enduring pillar of faith for Goldblatt, who has long viewed the workshop as more than simply a place to learn technique. At its core, apartheid sought to create a black underclass denied of any imaginative agency. Imagination, therefore, is necessarily subversive. To focus only on technique, without cultivating a critical vocabulary of image-making, would have reinforced the logic of apartheid, which accommodated for low-level black artisans. But Goldblatt's philosophy, which was vigorously championed by Fleetwood during his tenure, can also come across as high-minded, especially in a transactional economy where knowing how to make an image can land you paid work.

"We did not teach people how to become effective commercial photographers," Goldblatt said of the workshop's earliest curriculum. "But we also learnt quite soon that is what people wanted and needed, badly." The curriculum was retooled to give future photographers, whether photojournalists or wedding portraitists, the necessary technical competencies to pursue a vocation. According to Fleetwood,

70 percent of all photojournalists in Johannesburg have passed through the workshop.

Tshepiso Mazibuko is still working out exactly what her interests are. Born in 1995 and raised by her single mother, she was introduced to photography by Lindokuhle Sobekwa, a high school friend and fellow workshop attendee, whose series *Nyaope* (2013–15) offers an uncompromising account of the intersection of township poverty and drug addiction. By contrast, Mazibuko's domestic interiors, made at various homes in Thokoza, east of Johannesburg, show the same absorption with the unspectacular and ordinary in black life as Santu Mofokeng's elegiac accounts of township life in the 1980s and '90s. In 2016, Mazibuko was invited to Addis Ababa, where she won the inaugural first-place Addis Foto Fest Award. Mazibuko's mother is impressed, up to a point. "If I tell my mom I have a gig, she asks: 'Are you being paid?' It is a constant thought at the back of my head: How do I provide?"

The strain of getting by while still keeping an eye on the bigger prize recurs in the biographies of many workshop students. For every star like Muholi and Bieber, Fleetwood told me, the workshop produces a great deal more graduates "who understand the long road, who work in regional and community media, who have set up portrait businesses or event photography businesses." Muholi, though, is an avatar of the workshop's past and future. "My life began there, to be honest. It defined me. It was a space for validation." A class with Fleetwood, who is also gay, pushed her to explore her own project with greater emphasis and led to the 2004 show *Visual Sexuality* at the Johannesburg Art Gallery, which, she said, "opened up so many doors."

Those doors, to run with Muholi's metaphor, have led workshop participants to unexpected places. In 2003, Bieber traveled to Valencia, Spain, to spend time photographing a community of HIV-infected drug users; her empathetic portraits of outsiders have much in common with Sobekwa's recent project on the fringe of Johannesburg. The ability to connect disparate geographies, and find not only affinities but also something approaching reconciliation, is best exemplified in Sekgala's abbreviated but luminous body of work. In 2013, Sekgala was an artist-in-residence at the Künstlerhaus Bethanien, Berlin, and Darat al Funun – The Khalid Shoman Foundation in Amman, Jordan. His extraordinarily quiet observations of street life in both cities recall a line from an influential 1984 essay by novelist and critic Njabulo S. Ndebele: "Here is a man during a moment of insightful intimacy with himself; a moment of transcendence." When Goldblatt hustled to establish a community-education program with "no racial barriers and no limits," such transcendence was merely aspiration, and the worldliness it might afford seemed unimaginable. Such is the distance between then and now.

The strain of getting by while still keeping an eye on the bigger prize recurs in the biographies of many workshop students.

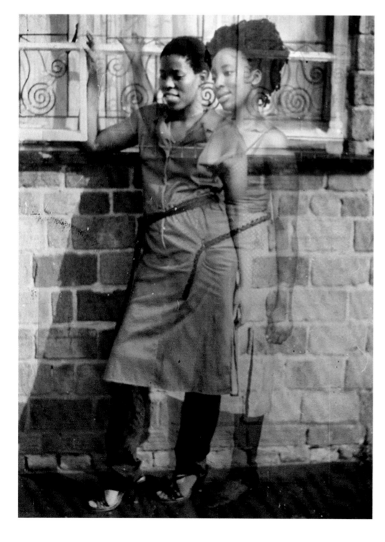

Sean O'Toole is a writer and editor based in Cape Town.

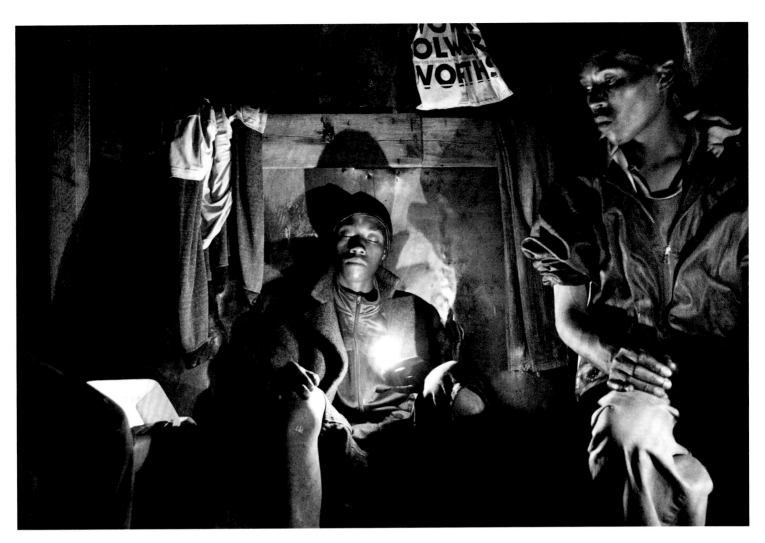

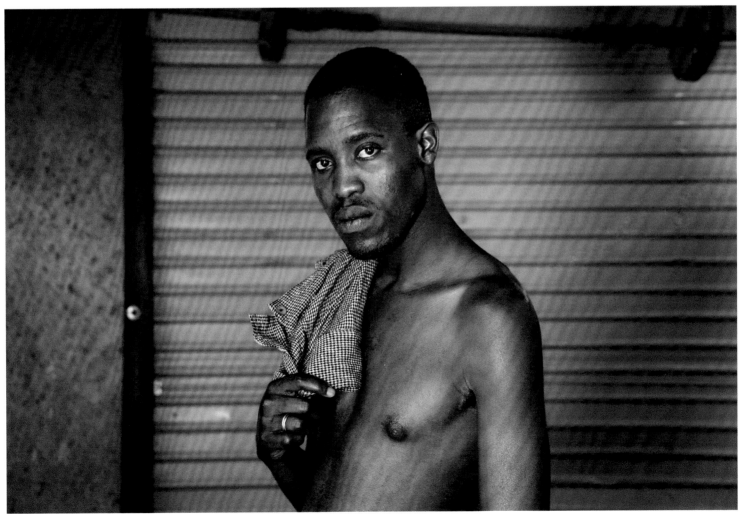

SABELO MLANGENI

Bongani Madondo

BIG CITY

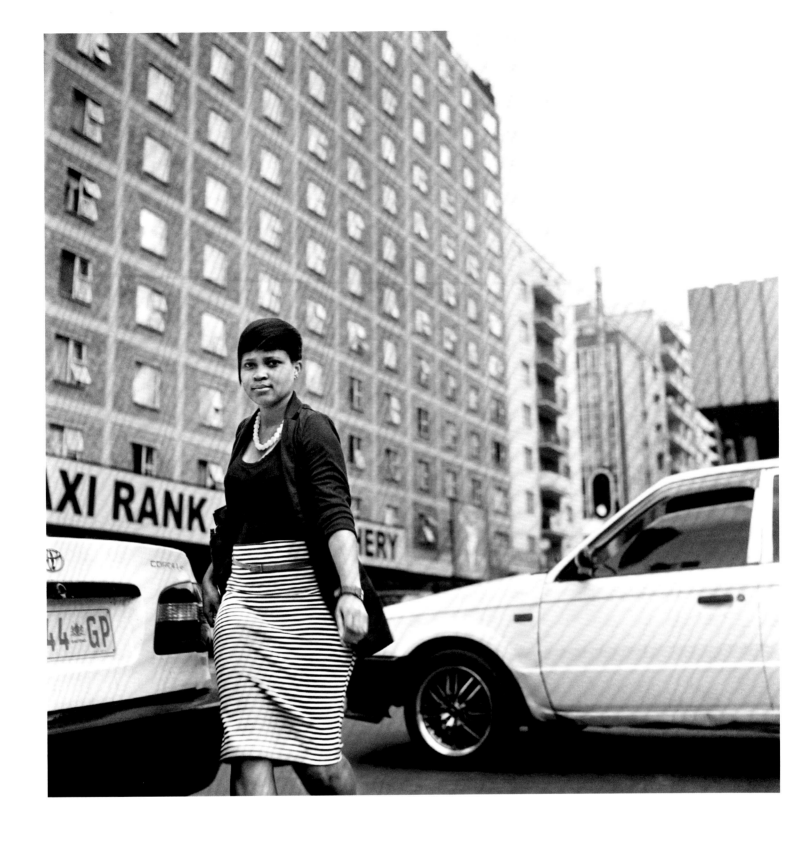

Woman and City, 2012

There's something achingly poetic and yet unsettling about Sabelo Mlangeni's work. This paradox is a reflection of the Johannesburg-based photographer's approach: a soul *quite* quiet, though audible in its silence. Because of this innate calm, Mlangeni succeeds in taking both subjects and audience into his confidence. A Zen-like trait gifts his work with a sense of welcoming reassurance.

On the other hand, his images convey a deeply satisfying, even ugly-beauty sensibility that is ultimately autobiographical. Their realism and presence are entrenched in Mlangeni's reluctance to press your face against the pulse of the city where he walks and shoots.

There's also something raw yet elegant here. Raw as in unfinished, although you cannot tell what exactly is missing. And the elegance of composition. The minimalist knack of uncluttering an already miasmic African megalopolis, Johannesburg, a place for which he nurses something of an intense love and hate.

Mlangeni first arrived in the big city in 2001, age twenty-one, raw from the woods, a place named Wakkerstroom ("awake ravine"), bordering the fabled republic of the Zulus, KwaZulu-Natal, and the equally proud Swazi kingdom. His only experience in photography was less than an assistant, more like a busboy, in the ramshackle studio of a village photographer, Mrs. C. S. Mavuso. In addition to cleaning up the studio for her, he ran on foot delivering postcard-style "snaps" to clients and collecting payments.

In Johannesburg, alienated and scared, he found home at the Market Photo Workshop, where he enrolled in an intermediate course—a thirteen-week introduction to photography that takes neophyte photographers through the basics of visual literacy and methodology, and offers them the use of equipment and in-house resources. But his enrollment in the workshop, thus his introduction to the city, did not quite translate into understanding the dynamics of the big city.

"A shock and shot to my system," he says, as both of us are hanging out the window ledge of his flat in the Johannesburg inner city, overlooking the streets of the place he has since reluctantly called home.

Johannesburg, then and now, is Africa's economic hub, a behemoth African bazaar, the nexus at which an exploding continental otherworldliness and a saturation of pan-African pavement capitalism smooch first-world architecture. The results throw up a city held thinly together by the ethos of convenience and active, almost punk-like dissonance.

Mlangeni recalls how his reception into urban life played out: "It was my first time ever in a city, let alone a city as improbably immense as Johannesburg. First time in a city, first time in *this* city, first time in a photography school." He struggled with everything. He struggled with English. He struggled with building friendships. "Everyone sounded like they were speaking in tongues. I could not communicate. I felt like an alien in the big city. So I turned my camera onto the buildings. The architecture."

His early photographs—like Eugène Atget's, a commentary on architecture as a site of both rapture and roots—focus on the city's contrast between constant rebuilding and retaining aspects of its past. Everywhere he went, new buildings were constructed on sites of existing ones, sometimes demolishing the old, but often having the old side by side with the new. *Johannesburg Circa Now*, an exhibition curated by Jo Ractliffe and Terry Kurgan, in 2004, featured Mlangeni's observations of urban life. "From then on I started looking at Johannesburg as a non-home." That sense of alienation served as the building blocks for *Big City* (2002–ongoing), a series that mellowed in gestation over time.

Out of this initial work Mlangeni's signature poetic style emerged. It's a technique—wide angles, smoky landscapes, eschewing loudness yet alert to the dramatic—not unlike those of the Johannesburg photographer Andrew Tshabangu, and the 1950s street photographers Ernest Cole and Bob Gosani, whose works are steeped in realism and celebrate the mundane and the everyday, traits Mlangeni himself has mastered.

Big City contains images of cinematic beauty, with poetic vérité in their accessibility. His dramatis personae tell stories that are disparate, dissonant vignettes, each in motion, without resolution, never intending to achieve resolution: Teenage girls posing like mannequins on the streets. Crammed low-rent living in the city center. A solemn-looking woman with round, haunted eyes. Roses sprouting out of the concrete slabs of the city.

For a photographer ill at ease with referring to his work as "art" and himself as a "photographer"—preferring instead "cameraman"—Mlangeni is a street photographer in its most historical sense, the ultimate flaneur—to wit, the Atget of Johannesburg.

Bongani Madondo is an associate at Wits Institute for Social and Economic Research in Johannesburg and the author of *I'm Not Your Weekend Special: Portraits on the Life+Style&Politics of Brenda Fassie* (2014) and *Sigh, the Beloved Country: Braai Talk, Rock 'n' Roll & Other Stories* (2016).

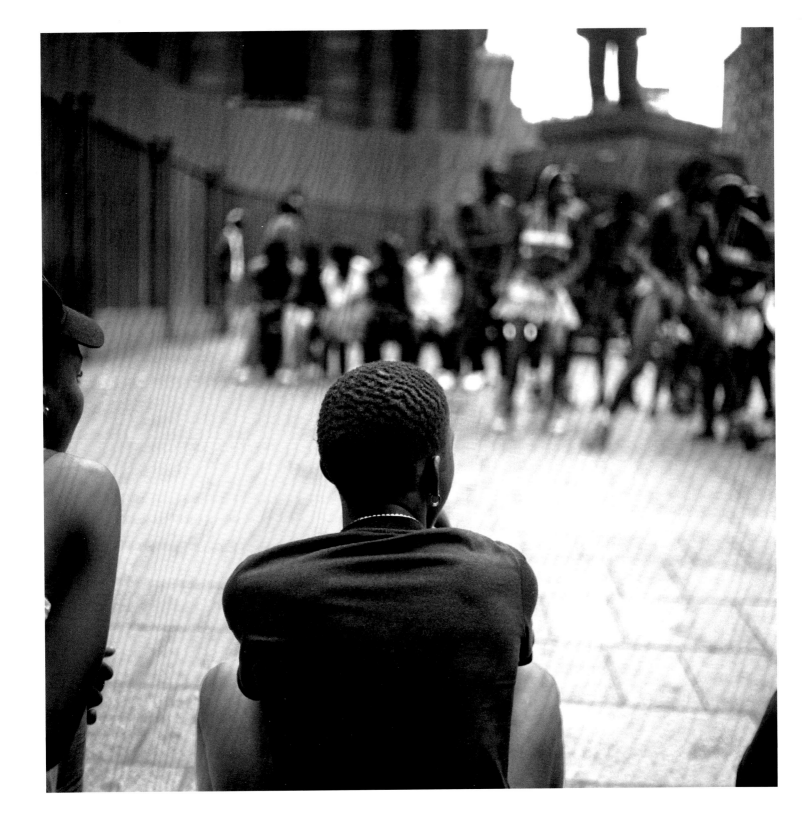

This page:
Looking at ..., 2011

Overleaf:
Isolezwe, 2012; *Torodi House, Jeppestown*, 2007

UKHAYA
WAMA-IDOLS

Isolezwe

NGIKULUNGELE
UKUQEQESHA
USUTHU:
MADIDA

Isolezwe

KUBULAWE
OMUNYE
USIHLALO
WE-ANC E-KZN

Amazing APRIL

LOANS!

HOME STUDY

NO TOLL ⬠AA GP

Taxi, 2010

***Coming to Johannesburg I,
January 2011***
All photographs from
the series *Big City*,
2002–ongoing
Courtesy the artist

DRUM

FASHIONS IN
CASUAL WEAR
— pictures

Africa's Leading Magazine

6d.

Registered at G.P.O. as a Newspaper.

JULY, 1956

In midcentury South Africa, *Drum* magazine was the destination for culture and politics.

Truth Telling & High Fashion

Rita Potenza

When Zola Maseko's film *Drum* was released in 2004, its poster featured the iconic red-and-white masthead of the eponymous South African newsmagazine, beneath which ran the tagline, "THE TRUTH SHALL SET YOU FREE." The American actor Taye Diggs plays the trailblazing investigative reporter and editor Henry Nxumalo; Gabriel Mann plays the photographer Jürgen Schadeberg; and the scenes of 1950s Sophiatown, a black area of Johannesburg, are shot through with a heady sense of stylish nostalgia for an era of fearless truth telling and high fashion. Such was the legend of *Drum* that, forty years after its golden age, the magazine would be subjected to a Hollywood-style reincarnation.

"*Drum* was the first to show the other side of the coin," the journalist Arthur Maimane recalled in 1989. "The black side of South Africa." Run by a group of Oxford dons and European immigrants, the magazine showcased black writers and photographers, and published South Africa's most significant news stories of the 1950s and '60s. Originally titled *The African Drum*, it was founded in 1951 by Robert Crisp, a journalist and broadcaster, and Jim Bailey, a British-born Royal Air Force pilot. Bailey, who found inspiration in the early American media mogul William Randolph Hearst, soon took full control of the magazine, and became synonymous with this unusually progressive adventure in publishing.

At its height, in 1959, almost a quarter of a million copies of *Drum* were distributed per month in eight countries in Africa— Ghana, Nigeria, Sierra Leone, Uganda, Tanzania, Kenya, Rhodesia

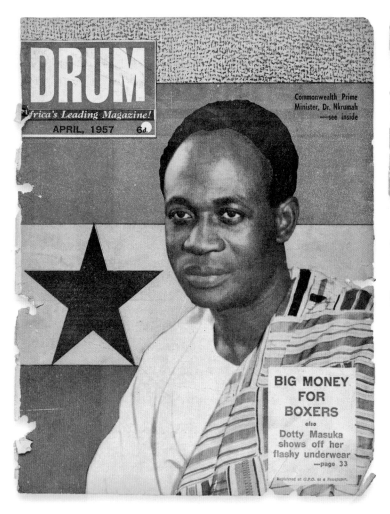

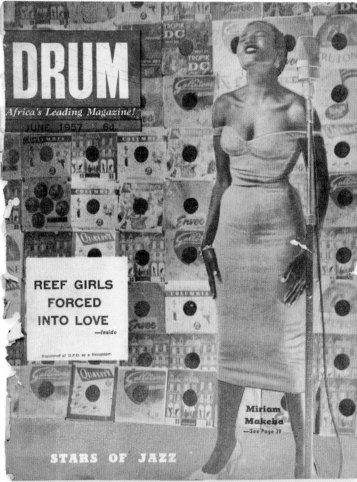

(now Zimbabwe), and South Africa—the largest circulation of any African magazine at the time. Though rooted in South Africa, the magazine maintained a pan-African footprint and cosmopolitan purview, with offices in West and East Africa, and in London. An anomaly in South African publishing at a time when black experience was subjected to misrepresentation, callous euphemism, and negative stereotyping at every turn, *Drum*, with its signature style and flair, celebrated black culture, while publishing exposés on the depths of suffering and degradation endured under apartheid.

Photography was key to *Drum*'s identity. Foremost in contributing to its rich visual legacy was Jürgen Schadeberg, a professional photographer who arrived in South Africa from Germany in 1951 and became the magazine's chief photographer and picture editor in Johannesburg, training photojournalists like Peter Magubane and Bob Gosani and working with Ernest Cole. The magazine's political features documented the social upheaval of the 1950s and '60s, which laid the foundation for decades of resistance to come. These included, in October 1952, an eight-page photographic feature on the Defiance Campaign, a nationwide mobilization of civil disobedience against the pass laws—a form of urban influx control preventing settling and freedom of movement in cities and suburbs that rendered black South Africans second-class citizens. *Drum* also covered the historic women's marches on the Union buildings in Pretoria in 1955 and 1956, during which thousands of women of all races converged to protest the pass laws. In 1960, the magazine published a feature story, with Magubane's elegiac images, on the Sharpeville massacre, when South African police opened fire on a large crowd of protesters gathered outside a Sharpeville police station, killing sixty-nine people and wounding over 180 more.

Drum's upbeat covers—featuring cheesecake photographs of Dolly Rathebe and Dotty Tiyo, among other *Drum* "cover girls," and snappy taglines—were sometimes at odds with the content inside. Schadeberg oversaw the cover designs, but the color confections were often the accidental result of being printed on an ancient tabloid press, bought secondhand from India. The covers were romantic, affirming, and escapist—though sometimes jarring dissonance surfaced between the cover girls and political headlines. "*Drum* writers and photographers really didn't think that apartheid and racism would last," Schadeberg has said, and the tone of reporting insisted that the daily trials and injustices faced by black people should be condemned. But there was a strong contrast between the racially integrated newsroom and the business management dealing with advertising and circulation, which was predominantly white. According to Schadeberg, those in management "would have been ashamed to be openly associated with the publication." Nearly 60 percent of the magazine consisted of advertising. It often promoted such things as toxic pharmaceutical products promising lighter skin and straighter hair.

Perhaps the defining feature of *Drum*, in addition to hard-hitting reportage, was its unabashedly joyful portrayal of black culture. The South African singer and antiapartheid activist Miriam Makeba's emergence as a star was first captured in *Drum* with the iconic image Schadeberg took of her for the cover of the June 1957 edition, which became indelibly associated with her persona. *Drum* was a potent visual chronicle of some of the hottest acts of the 1950s, such as the Manhattan Brothers, the Harlem Swingsters, sultry singer Dolly Rathebe, and the cast of the musical *King Kong*. Recording this new, black urban culture, the magazine was one of the only platforms for aspiring black authors like Todd Matshikiza, a composer and music reviewer who rendered Johannesburg's jazz scene in exuberant prose: "Brothers ... I've got smashing news for you. Real hot poker stuff. The kind of dope you get once in a blue moon. D'you know King Force? Hey? The big broad-shouldered hawk-eyed veteran sax maniac? The chap that's the life blood of the great Jazz Maniacs Orchestra of Johannesburg? You should know who I'm talking about man."

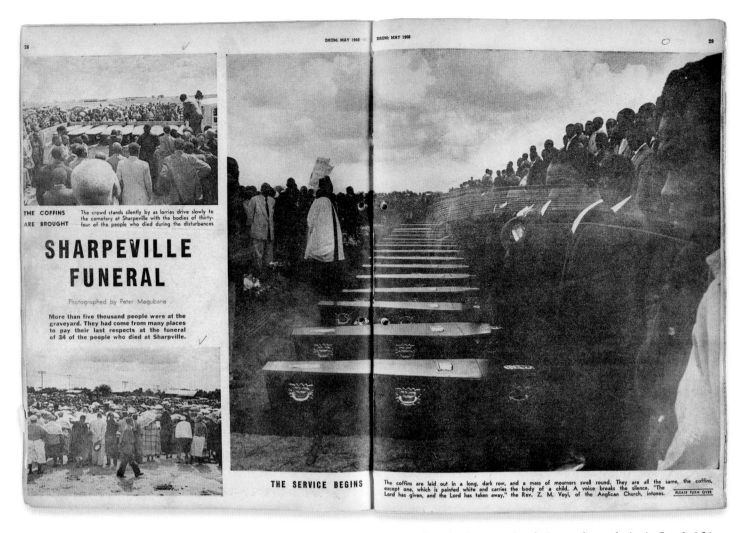

THE COFFINS ARE BROUGHT The crowd stands silently by as lorries drive slowly to the cemetery at Sharpeville with the bodies of thirty-four of the people who died during the disturbances

SHARPEVILLE FUNERAL

Photographed by Peter Magubane

More than five thousand people were at the graveyard. They had come from many places to pay their last respects at the funeral of 34 of the people who died at Sharpville.

THE SERVICE BEGINS The coffins are laid out in a long, dark row, and a mass of mourners swell round. They are all the same, the coffins, except one, which is painted white and carries the body of a child. A voice breaks the silence. "The Lord has given, and the Lord has taken away," the Rev. Z. M. Voyi, of the Anglican Church, intones. PLEASE TURN OVER

Opposite, left:
Prime Minister Dr. Kwame Nkrumah, who piloted Ghana to freedom, on the cover of *Drum*, April 1957

Opposite, right:
Miriam Makeba on the cover of *Drum*, June 1957

This page:
Spread on the Sharpeville funeral from *Drum*, May 1960, including photographs by Peter Magubane
All images © Bailey's African History Archive

Drum celebrated black culture, while publishing exposés on the degradation endured under apartheid.

Despite its mass circulation and popularity in South Africa, and its coverage of communist political figures and those on trial for treason, *Drum* was never banned, seized, or censored by the state. Today, the Bailey's African History Archive (BAHA) in Johannesburg, which holds the *Drum* archives, remains the preeminent visual record of key historical events, since much political imagery was lost to rampant state censorship. In South Africa the archive is being revisited by historians, filmmakers, and stylists, offering increased recognition for figures in black political and cultural history. The contributions of writers like Henry Nxumalo, Todd Matshikiza, Nat Nakasa, Can Themba, and Es'kia Mphahlele, and of photographers like Schadeberg, Bob Gosani, Peter Magubane, Alf Kumalo, Ernest Cole, Ranjith Kally, and Ian Berry are critical to understanding the literary and photographic oeuvre of the period. Photobooks, such as Schadeberg's *The Black and White Fifties* (2001), *The Finest Photos from the Old Drum*, and *The Fifties People of South Africa* (both 1987), produced by BAHA, as well as the documentary film *Have You Seen Drum Recently?* (1989), revisit the excitement, glamour, gossip, and intrigue of the black social scene, the fashion icons, entertainers, musicals, beauty queens, and fast-living gangsters from across South Africa. Together, these contributions remind readers of the mood of a bygone era, South Africa during its turbulent midcentury, as expressed through the pages of a dynamic magazine.

Rita Potenza is a photo researcher, instructor, and archivist based in Johannesburg.

When Madagascan-born, Paris-based artist Malala Andrialavidrazana obtained her degree in architecture in 1996, France's economy was still recovering from the global recession of the early 1990s and high unemployment during the socialist era of François Mitterrand. To support herself, the young architect cut her teeth in the Parisian art scene through a range of jobs, including stints directing art galleries. These experiences burnished her regard for the analytical possibilities of photography and the peripatetic nature of artistic inquiry.

A decade later, Andrialavidrazana began a career as an artist by extending her graduate investigation of Madagascan burial architecture to cities throughout the Global South—Auckland, Buenos Aires, Guangzhou, and Santiago, among others. The resulting series, d'Outre-Monde (2003), which cross-examines funereal traditions and urban architecture, jumpstarted Andrialavidrazana's international visibility and earned her the prestigious Prix HSBC pour la Photographie in 2004. The following year, the series appeared in the sixth Bamako Biennale, marking the first of her many engagements with audiences on the African continent.

Over the years, Andrialavidrazana has consistently demonstrated an ethical commitment to countering photographic representations that construe Indian Ocean cultures as exotic. For her series Echoes (from Indian Ocean) (2011–13), she traveled throughout the Indian Ocean region—home to one of the world's earliest global economies—documenting the afterlife of centuries of cultural exchange as distilled through religious iconography and furnishings displayed in homes. Echoes began in Andrialavidrazana's birthplace of Antananarivo, and developed further in Réunion, Durban, and Mumbai. The series captures middle-class life in fragmented compositions that elicit transhistorical impressions of urban design.

Andrialavidrazana's most recent project, Figures (2015–ongoing), consolidates the global purview, comparative structure, and multiple temporalities of her past work into a series of formally and ideologically saturated cartographic plans. Each work in Figures retains the title and bears traces of a different nineteenth-century map the artist appropriates as a ground for overlaying—through digital photomontage—pictorial elements excised from atlases, currency notes, and other archival materials from different regions of the world. Recalling Europe's nineteenth-century remapping of Africa into colonies, Andrialavidrazana's palimpsests dramatize past uses of cartography to distort history, assert power, and economically exploit lands and peoples through conquest.

In 2015, Andrialavidrazana returned to Mali to present Figures in the tenth Bamako Biennale. The show's overarching exploration of storytelling underscored the work's reproach of myopic historiographies of mapmaking in Africa that privilege European cartography of the continent to the detriment of local mapmaking traditions. Through her artistic pursuit of cartography, Andrialavidrazana becomes heir to a rich, though relatively understudied, tradition of African mapmaking as exemplified by ancient Egyptian geological maps, Tigrean circle maps of the Aksumite Empire, and lukala wall maps of the Luba peoples.

Figures alludes to these histories of cartography by convolving a bounty of locally specific motifs and actors: Nefertiti, Nelson Mandela, Mobutu Sese Seko, female Malagasy warriors, nomadic Lesothan shepherds, and a wealth of indigenous flora and fauna. While Andrialavidrazana painstakingly researches each motif to devise these elaborate compositions, she ultimately aims, in her words, to "remove the borders of meaning around specific imagery to inspire cross-cultural associations." On this score, Figures reverberates with fantastic provocations not only for rethinking historical uses of maps, but also for speculating on the future role of borders in governing human exchange.

Malala Andrialavidrazana

Antawan I. Byrd

Antawan I. Byrd, a PhD candidate in art history at Northwestern University, was an associate curator of the tenth Bamako Biennale (2015).

Figures 1889, Planisferio,
2015

Figures 1838, Atlas
Élémentaire, 2015

Mimi Cherono Ng'ok

Hansi Momodu-Gordon

"Beyond the edge of the world there's a space where emptiness and substance neatly overlap, where past and future form a continuous, endless loop," Haruki Murakami writes in *Kafka on the Shore* (2002). "And, hovering about, there are signs no one has ever read, chords no one has ever heard."

In her recent photographs, Mimi Cherono Ng'ok calls us to places at the edge and along the shore, away from the spectacle of stereotypes of Africa, and toward the beauty residing in everyday life. "I am drawn to those spaces where there are either two things opposing, or existing without a direct relation between them," Cherono Ng'ok said earlier this year, reflecting on how her choice of subjects has been shaped by feelings of unfamiliarity in Nairobi, where she was born and raised, but which hasn't always felt like home. The constellation of images in this portfolio, drawn from her first monograph, *Always, in Spite of Everything* (2016), contains an elusively subtle form of power. Cherono Ng'ok offers a reminder that in moments of stillness—as we stand beside a companion on the beach contemplating recurrent waves, or pause at the threshold of an open door—we can feel most alive.

Cherono Ng'ok is of a generation of African artists who have found a spotlight for themselves on the world stage without having to move to Europe or America. In 2002, she left Nairobi to begin a BFA in photography at the Michaelis School of Fine Art at the University of Cape Town, graduating in 2006. But the Eurocentric curriculum leaned toward histories and practices in the United Kingdom or United States, with little acknowledgment of what was happening on the continent. Moving to South Africa also made Cherono Ng'ok a stranger, giving her a taste of how those who are from the "outside" are treated and, crucially, how experiencing new places causes disorientation upon returning to the familiar—a trope that surfaces consistently in her photography.

Cherono Ng'ok has become part of a burgeoning network of artists, writers, filmmakers, and creatives across Africa who are participating in platforms such as the Market Photo Workshop; the itinerant Àsìkò International Art School, organized by the Centre for Contemporary Art, Lagos; RAW Academy at RAW Material Company in Dakar; festivals in Bamako, Dakar, Lagos, Abidjan, Addis Ababa, Douala, and Lubumbashi; and Photographers' Master Class programs, initiated by the Goethe-Institut Johannesburg and curator Simon Njami.

In 2011, at the Photographers' Master Class held during the ninth Bamako Biennale, Cherono Ng'ok worked with Thabiso Sekgala and Musa N. Nxumalo, both alumni of the Market Photo Workshop and known for their photography of South African youth and culture. Together, they devised an exhibition of their own work, *Peregrinate: Field Notes on Time Travel and Space* (2014). The exhibition includes Cherono Ng'ok's images from *The Other Country* (2008–16) and *No One but You (Dakar)* (2014) alongside Sekgala's *Homeland* (2009–11) and Nxumalo's *Alternative Kidz* (2009), and explores their relationships to movement through place, as well as journeys of self-discovery. *Peregrinate* continues to tour extensively in Africa, evolving as it travels from city to city. For Cherono Ng'ok, the exhibition is an important "opportunity for people to see work being made here, to interact with it, and discuss it."

Cherono Ng'ok has developed an openness to her image-making that moves beyond the documentary. Shooting daily, she responds to her feelings about a particular place. Accumulated pictures are later revisited and curated into changing configurations for display. She has maintained a deep connection to Sekgala, who died suddenly in 2014, and the work she made in the six months following his death resulted in an elegiac meditation. From this experience, Cherono Ng'ok began to read her surroundings, and the pictures made in them, through loss, absence, and regret, allowing the images to appear like her memories—fragmented.

Hansi Momodu-Gordon is an independent curator and writer based in London.

All photographs
Untitled, 2014
Courtesy the artist and
Tiwani Contemporary,
London

Nico Krijno

Sara Knelman

What is a photographic synonym? Can one image stand in for another? How do these subtle slips of meaning and understanding, so fundamental to language, work visually? For South African artist Nico Krijno, the game of comparing, translating, and constructing affinities plays out in buoyant pictures arranged in whimsical sequences. Fresh tropical flowers are set against busy textiles; mismatched push-button telephones sit playfully, like interlocking slinkys, on concrete steps. When gathered together in books, including *Synonym Study* (2014) and *New Gestures* (2016), the experimental energy of these images shows a manic attention to the contiguities of perception, leaving much for the eye to linger over and around—exuberant colors, clashes of textures and patterns, unlikely juxtapositions, and visual paradoxes that twist our sense of logic and perception.

There have been fires in the countryside around the farmhouse, outside Cape Town, where Krijno lives with his wife and two-year-old daughter. It means, Krijno told me, that they've been up nights, forced to evacuate when the danger comes too close. Yet he also describes an idyllic picture of life there, slower and more connected to nature, for his young family. Krijno works mainly out of a small studio on the property, with enough room to erect the makeshift sculptures that often serve as inspiration for his photographic work. It's hard not to conjure the old metaphor of the artist's studio as a stand-in for the inner workings of the mind—a place for pouring out a mess of ideas and eventually building something coherent. His subjects—whether physical objects or digital constructions—appear precarious and fleeting, almost tragically insufficient, changing shape as elements shift and settle, or even fall apart altogether, only to be rebuilt anew as mash-ups of themselves. And, as images amass, their component parts—material, formal, graphic—reappear, recycled and repurposed in new combinations.

A sense of physical place comes through in the bodily relation and attentiveness to the objects Krijno dredges up, and in the "found" sculptures they're often set against: seemingly banal elements, like fences or dilapidated buildings chanced upon in the surrounding landscape, sometimes flattened or repeated as obviously digital motifs. They are emphatic responses to immediate surroundings, yet they bear little direct relation to geographic specificity. As flattened photographs, they instead collapse into peripatetic and lustrous surfaces, clean and sleek and easy to circulate. With a background in theater and film, Krijno is more inclined to invent new worlds than record this one. His imaginative transformations resonate with an international network of young artists exploring the overlaps and interconnections among photography, sculpture, and performance. It's not surprising, then, that Krijno finds his community online—rather than in his own backyard—where images float loose in the apex of constructed image-worlds.

All photographs
from the series
Synonym Study and
New Gestures, 2011–17
Courtesy the artist;
The Ravestijn Gallery,
Amsterdam; and
Beetles+Huxley, London

Sara Knelman is a writer, curator,
and lecturer living in Toronto.

Jody
Brand

Jenna Wortham

Africa is often defined from the outside. Throughout history, works about the continent—films, photographs, and books— have rarely come from the people living those realities. Centuries of colonization and oppression have kept Africans from authoring their own narratives. But recent years have seen the rise of young African photographers, including Zanele Muholi, Siphiwe Sibeko, Neo Ntsoma, and Jody Brand, who challenge those notions and define reality on their own terms.

Brand brings an unmistakable Internet aesthetic to her photography. She is twenty-seven years old, so social media has defined how she interacts with the world beyond her own. For Brand, growing up in Cape Town, the Internet became a portal and a safe haven, telegraphing relief and comfort by showing how people of color live in the world. It was a place where she "realized you can be a person of color and different and alternative." It's why she still uses a Tumblr account to publish the majority of her work: the openness and accessibility of the platform make it available to others, like her, who crave their reflection online. The name of her page, *chomma*, comes from the slang for "friend"—signaling the lens that she is offering into her world, as well as the hand she is extending out to others.

Brand began taking photographs because she felt non-Africans were still owning the conversation and dialogue about African identity. "People who insert themselves within a situation and take what they want and leave—it felt very *National Geographic*," she told me. It made her question what she was seeing—and ultimately, what the world was seeing. "They're not adding anything to the conversation or the culture," she said, "they're just colonizing it."

Some photographers' work, she feels, still observes and potentially uses Africans as subjects, not protagonists. "There are a lot of power dynamics involved with photography," she said. "Photography carries so much baggage, especially on the continent." Brand uses a cheap plastic point-and-shoot. She doesn't have a car, so she walks or takes public transportation. The images she makes come from personal interactions she has on a daily basis.

Brand initially planned on becoming a journalist. She enrolled at the University of Cape Town with the hopes of giving the marginalized and the underreported community a voice. But she found the experience to be traumatizing, and the educational system to be entitled and colonialistic. "I really hated everything I was being taught," she said. She turned to photography and began pursuing a career in fine art, working for art directors and assisting on shoots.

Brand tends to photograph her friends, and there is an undeniable intimacy to the work. It is as tangible as an item of clothing. "The struggle of living in Cape Town is being belittled and dealing with covert racism, like the way the city is planned so that white people don't deal with the reality of the majority of the people in this country because they keep them out of sight," she said. "There are limitations to what you can do as a young person of color in this city." Her work is about allowing black people the opportunity to look at themselves with "love and dignity." "I take pictures of people to remind them they are beautiful and worthy and part of something and they belong to something greater."

Occupying space—in someone's mind, on a screen, in a gallery—is a form of protest that functions on a number of levels, internally and externally. For Brand, as a nonwhite South African, "we navigate spaces in an almost apologetic way. I want to do the complete opposite in a reckless way." She makes images that stand in defiance of white expectations and don't adhere to any aesthetic other than her own. They present young black and brown Africans flourishing under oppression, and influenced by popular Internet culture. Ultimately, Brand hopes to offer a lifeline to others, like her, who feel disenfranchised by the culture of their environment. "To me, that's the power of art," she said.

Jenna Wortham is a staff writer
for *The New York Times Magazine*.

This spread:
Exorsisters, Cape Town,
2012

Overleaf:
Sam, Cape Town, 2012;
Kitty de la Renza, Cape
Town, 2015
All photographs courtesy
the artist

Ashley Walters

Candice Jansen

Ashley Walters's breakout series *Uitsig* (2013) addresses the community of the same name in Cape Town where the photographer was born. *Uitsig* means "landscape" or "view" in Afrikaans and is a place that Walters describes as "a small community situated between informal townships, industrial zones, open spaces, a cemetery, the main road, and a railway line." It is located on the Cape Flats, an area developed over the course of the twentieth century with the rise of urbanization, racial labor policies, and apartheid forced removals. During South Africa's apartheid regime, places like Uitsig were designated for those classified as "Coloured," a 106-year-old state category of person that during apartheid was redefined to mean being neither black, Asian, nor white.

Walters may picture historic Coloured-only spaces like Uitsig, but his photographs are not just about race. Contemporary identity-centric works and visual practice in South Africa can be vulnerable to a fixation on apartheid and its ways of legislating a sense of belonging. Instead, Walters leans on other kinds of identity to describe the experience of making the series. He had, in his own words, "changed from being a son, brother, uncle, cousin, friend, and community member to being a photographer."

The series chronicles this homecoming but guards against nostalgia, despite drawing from the imagination of Walters's childhood spent in Uitsig. He remembers that, as a child, "while my friends freely roamed the neighborhood, I was kept behind closed doors and felt like a prisoner desperately yearning to escape the confines of his cell." His maternal grandparents, who raised him, kept Walters from a world of dangers, which also gave him the freedom to invent stories. He occupied his time with cutting out pictures from magazines for collages and

making his own VHS films from recorded television programs. As he grew older, Walters began photographing his family, which he has been doing now for almost fifteen years.

After leaving Uitsig for some time, Walters cut his teeth on jobs such as restoring old, hand-painted family photographs, and took his final high school exams several times over to improve his grades. This determination is how he gained admission to the prestigious Michaelis School of Fine Art at the University of Cape Town, another world just fifteen miles away from Uitsig.

Walters admits to spending time composing scenes, rather than capturing more spontaneous, candid photographs. He moves through community spaces like a cinematographer, paying close attention to the material life of things and their play with luminosity across fabric and concrete. The life of things also becomes a dynamic life of color in places like Uitsig that historically have been photographed mostly in black and white and rarely at night. Walters makes a familiar sight also strange by casting both the shadow and the shine of Uitsig into a carnival of light where windswept girls in a beauty pageant appear larger than life.

This portfolio may end on a stage at the Ravensmead Secondary School fair, but it begins in a home on Lantana Road in Uitsig, "a place without a post office," Walters says, "a place that has never really been on the map." Until now.

Candice Jansen is a PhD candidate in art history at Wits Institute for Social and Economic Research, Johannesburg.

Page 94:
Flowers, Lantana Road,
Uitsig

Previous page:
Aunt Freda, Eureka

This page:
"Kos Koepon" Ravensmead
Annual High School Fair,
Ravensmead

Beauty Pageant,
Ravensmead Annual High
School Fair, Ravensmead

All photographs from the
series *Uitsig,* **2013**
Courtesy the artist

Zineb Sedira, *Haunted House*, 2006
© the artist and DACS, London, and courtesy the artist and kamel mennour, Paris/London

Raw Land

How are artists rethinking documentary in North Africa?
Morad Montazami

If we were to attempt to chart the photographic practices of the Maghreb region, it's unlikely that we'd end up with the expected map, divided into three neat slices of national territory: Morocco, Algeria, and Tunisia. Rather, we'd have an opaque diagram, tangled with intertwined roadways, hybrid landscapes, and fragments of experience to be retraced. Following Roland Barthes's notion that "photography is unclassifiable," it seems that a desire to classify this region geographically or culturally would lead inevitably to colonialist or neo-Orientalist stereotypes. How, then, might we avoid simply filling the need for "counterrepresentations" in the face of clichés that still feed art fairs and platforms? How might we consider the "inactive" or undesignated frontiers, rather than the current boundaries inherited from colonizers—such as the border between North Africa and sub-Saharan Africa?

Zineb Sedira (a Paris-born Algerian, now based in London) and Yto Barrada (a Paris-born Moroccan, living in New York and Tangier) are two prolific artists who are addressing the documentary image's spaces of redefinition. They find themselves at the juncture of postcolonial studies and an aesthetic of territorial, fluvial, geological,

and meteorological edges—a political ecology in which the scars of living beings are as valid as those of a country road or of an entire ecosystem. Just as Tangier and Algiers lock eyes in a vast oceanic mirror, the figures looking out at the great sea in Barrada's 2003 triptych *Belvédère* seem to find their exact counterparts in Sedira's 2006 diptych *Transitional Landscape*, where a figure also contemplates the sea. An encounter of two Mediterranean dreamscapes? But this dream has become a nightmare—a sea cemetery—as the migration crisis accelerates.

There is another point of contact for these two artists— that of placemaking, of opening paths for a new generation of artists interested in inhabiting frontiers: of photography and film, sculpture and installation. Barrada is a cofounder, and director since 2006, of the Cinémathèque de Tanger, which has played a central role in the contemporary Arab art scene. In Algiers, in 2011, Sedira founded the Aria Artist Residency, which hosts artists from North Africa and around the world who are working across boundaries. Both ventures, as they plant the seeds of cultural development, have created new networks of practitioners, critics, and viewers in their cities through exhibitions, workshops, speaker series, and, at the Cinémathèque de Tanger, even a "viewing school" for children.

Long before the start of the 2000s, a new, medium-centered documentary photography began to emerge mainly in Morocco, less open to interdisciplinary hybridization yet symptomatic of a moment at which the photobook had a particular prestige and newness. We might cite, for example, the memorable photographs of Daoud Aoulad-Syad's *Marocains* (1989) and Souad Guennoun's *Les incendiaires* (2000), which had clear ties to the work of leading intellectuals and authors, such as Abdelkebir Khatibi and Zakya Daoud, respectively. Cultivating an alliance between street photography and metaphorical autobiography, these photographers were impacted by both travel literature and the haunting aura of "the decisive moment," per Henri Cartier-Bresson and Robert Frank.

Tangier is the most captivating of "incendiary" ports of call for Guennoun, who with her camera follows Morocco's vagabond children, without home or family, delivered into the claws of the street. Its status as a "transitional city," a limbo zone between two worlds, attracts photographers eager to try to capture its mystique. In the same way that one never "sees" New York but can only "re-see" it (because of its innumerable photographic and filmic representations), Tangier carries the sense of déjà vu that is characteristic of particularly photogenic cities, with its teeming medina, its hushed 1970s-vintage hotels, its cinemas and abandoned theaters with their ghostly marquees, the traces of the Beat Generation and of Jean Genet, who described Tangier as a "fabulous city … the very symbol of treason."

But the romantic myth of Tangier also warrants a more analytical gaze, as in the work of Barrada, which examines its zones of exclusion, its blind spots, its blank spaces. This task has been taken up by the new generation of Tangerine photographers, foremost among them Hicham Gardaf. Investigating the underside of urban development and the nonplaces of globalization, he seems almost to make a synthesis of photography that *tells* and photography that *analyzes*. For a bit, Gardaf manages to get us to "see" Tangier, finally. There is a connection here to Wassim Ghozlani's 2016 series *Postcards from Tunisia*, which was featured at the 2016 iteration of Photomed, the annual festival of Mediterranean photography in Sanary-sur-Mer, France. Ghozlani's antipostcards purport to show Tunisian tourist spots, but do so via mute images of nonevents: a deserted crossroads, a bottle on a shelf, a broken door, or a hostel where visitors pasted their snapshots to a wall. Whereas Gardaf takes great care in the portrayal of his characters—although their function is limited to inhabiting the landscape—Ghozlani often captures spaces devoid of human presence, evoking memories of photography's earliest days.

Benohoud used the confines of the classroom as a setting, placing his young students in situations that are incongruous to the point of surrealism.

These photographers' practices—which are linked more to a fabrication of "the real" than to the documentary tradition—have an instructive model in Hicham Benohoud's series *La salle de classe* (The classroom). In this long-haul project, undertaken in two stages between 1994 and 2002 when he was an art teacher in Marrakech, Benohoud used the confines of the classroom as a setting, placing his young students in situations that are incongruous to the point of surrealism. It is as if the artist were seeking to mimic the dynamics of domination that reverberate throughout the society that lies just outside the four walls. The metaphorical power of these images—and the ingenuity of the "sets" cobbled together from the accoutrements at hand in an art classroom—have brought *La salle de classe* much attention: it was exhibited at the 2014 Marrakech Biennale and acquired by the Marrakech Museum for Photography and Visual Arts and London's Tate Modern.

In addition to art fairs and museums, both crucial platforms, the development of photographic practices in Morocco can be credited to new exhibition and publishing ventures. Rabat's Kulte Gallery & Editions, by creating a proper artistic research platform, articulated through a residency program, has proved influential since it opened in 2013. Its 2014 publication *New Africa*, a groundbreaking overview of the continent's impulse for photography and video, perfectly illustrates founder Yasmina Naji's rethinking of preconceived national and cultural boundaries. "The development of photography not only as a tool for identity tracing but also a catalyst for identities in motion," she says, "is what we hope to highlight in our program, as we also need to overcome the artificial boundary between so-called North Africa and the sub-Saharan territory."

With a clear commitment to women artists, Kulte recently showcased the refinement and compelling irony with which Carolle Bénitah infuses her embroidered photographs, turning intimate

Previous spread:
Wassim Ghozlani,
Postcards from Tunisia,
2016
Courtesy the artist and
Maison de l'image, Tunis

This page:
Zied Ben Romdhane,
Site of phosphate
processing, Redeyef,
Tunisia, March 21, 2015,
from the series *West of Life*
Courtesy the artist

memories and archives into mechanical mementos (for example, in *Le désert de Sodome,* 2016). Also confirming Morocco's step forward is Galerie 127 in Marrakech, the pioneering photography venue opened by Nathalie Locatelli in 2006. Locatelli's experience and undisputable expertise have allowed her to bring together established local photographers (Malik Nejmi, Aoulad-Syad, Benohoud) with emerging ones, such as Hicham Gardaf, but also foreigners (DaeSoo Kim, Denis Dailleux). These proactive gallery spaces have paved the path for newly established larger institutions, such as the Marrakech Museum for Photography and Visual Arts. (The latter is temporarily closed in anticipation of resettlement on a new site, after a highly promising two years.)

During the 1990s, the magazine *Revue Noire* helped lead the way for the boom of galleries and art spaces occurring in North Africa today. Published from 1991 to 2001, it was one of the first independent media outlets to offer African photography a distribution platform, showcasing its artistic direction and cosmopolitanism (with a focus that included everything from Abidjan, Kinshasa, Johannesburg, and Marrakech to New York, Tokyo, and beyond). Its Paris-based—and thus French-speaking—editors facilitated exchanges with the photographers of the Maghreb. It was a role that was all the more important at the time, as news agencies did not welcome Arab photographers as readily as they do today, and galleries and biennials had not yet absorbed new approaches to documentary.

However, the Arab Spring of 2010–11 provided photography with a new role, accelerating the emergence of "citizen photojournalism"—by violating the long-standing taboo against photography in heavily controlled and supervised public spaces of the Maghreb countries. In Tunisia, a postrevolutionary generation of artists and photographers is only now beginning to take shape. Last year, the *Washington Post* published a series titled *West of Life* (2016) by Zied Ben Romdhane, realized in Tunisia's Gafsa region. The project, which received an unanticipated level of attention,

In the Maghreb, documentary-style and humanistic photography have given way to an art of investigation.

Carolle Bénitah,
*muqueuse nasale
(nasal mucosa)*, 2012
Courtesy the artist and Sous
Les Etoiles Gallery, New York

shows with exceptional accuracy the stigmas and other "scars" left by phosphate mines on inhabitants and workers, as on the landscape itself. It reveals not only the photographic talents of Ben Romdhane, but also his ingenuity in distributing his images on social media without passing through an agency or other intermediary.

Speaking to new forms of image distribution, the project *Cairo. Open City: New Testimonies from an Ongoing Revolution* began as an exhibition at the Museum für Photographie in Braunschweig, Germany, in 2012, and traveled across the country, as well as to a gallery in Dubai. Its catalog (2014), edited by Florian Ebner and Constanze Wicke, is an archive devoted to the double revolution— political and visual—that took place at Cairo's Tahrir Square in 2011, including news and blog images, Flickr accounts, anonymous photographs, and works by artists such as Lara Baladi and Randa Shaath. The project shows that if indeed "photography is unclassifiable," it must "organize" in order to better operate in the outsider zones of insurrectional imagery.

The overlap of photography's hyperdistribution with the dizzying sociopolitics of an entire region augurs well for a very wide range of formats and platforms still to be invented. Through this acknowledgment of infinite particularities, focus shifts to the idiosyncratic, individual voice. In 2010, Zineb Sedira completed her video installation *Gardiennes d'images* (Image keepers), an investigation into the photographic work of Mohamed Kouaci, notably his epic experiences as a photographer during the Algerian War of Independence. What Sedira tells us through the work of Kouaci—more than half a century after his photographs were made—is that photography can no longer be defined simply as a "fine art," nor as purely subjective evidence. In the Maghreb, at least, documentary-style and humanistic photography have given way to an art of investigation in which one author's subjectivity calls out to those of others, seeking to join his or her solitude with the solitude of others.

Morad Montazami is Adjunct Research Curator for the Middle East and North Africa at Tate Modern and Director of Zamân Books.

Translated from the French by Diana C. Stoll.

DIARY

Abdo Shanan

EXILE

Kaelen Wilson-Goldie

The photographs in Abdo Shanan's series *Diary: Exile* (2014–16) take viewers by the hand and race them through a vertiginous world of gritty, everyday intimacies. Imagine Nan Goldin and Diane Arbus meeting Roger Ballen in the inner cities of twenty-first-century Algeria to produce work that none of them had the background or experience to perceive. More often than not, Shanan frames his images from above or below. He points his camera up to catch a shredded campaign poster or the face of a woman laughing, down to catch a splash of white paint on the sidewalk, a hand on a leopard-print coat, or a pair of lovers rolling on the ground. In Shanan's series, there are friends, strangers, twins, soiled bedsheets, signs of poverty, hardship, and distress, as well as moments of unguarded pleasure.

Shanan was born in the Algerian city of Oran in 1982. His family left just before the start of the civil war, which erupted in 1991 and tore through the country chaotically until 2002, when the conflict didn't so much end as exhaust itself. Shanan's father was a professor of international law. He moved the family to Sirte, in Libya, where Shanan grew up among an international crowd. Shanan's friends were the children of people from across Africa, Asia, and Europe who were there to work in universities, hospitals, oil and gas industries, and construction. Unfortunately, he graduated from university just as Muammar Qaddafi imposed a law prohibiting the employment of non-Libyans. That left Shanan with time on his hands. He filled it by taking pictures—first with the camera on his mobile phone, and then, when that was stolen, with an analog camera.

Shanan belongs to a pivotal generation in the history of photography, the first to be born in a totally digital age, the first to move anachronistically from the flood of images online back to film, chemicals, equipment, and developing pictures in a darkroom. "Photography is my fourth language," says Shanan, who returned to Algeria in 2009 and now lives in Oran. (His first, second, and third are Arabic, French, and English.) But black-and-white film has to be imported from Europe and is now extremely hard to find in Algeria. And, on various levels, Shanan continues to find his homecoming frustrating. "I thought coming back here would bring me home, but it didn't," he says. The country had changed, and so had Shanan during his time away. "It was difficult to find common ground. This led me to do the diary. It created a kind of exile for me."

Diary: Exile is part of a trilogy that Shanan aspires to complete as a means of capturing the fullness and complexity of his own identity. It begins with Algeria and will be followed by accounts of Libya and then of Sudan, where his father is from. Working on the project, he has come into contact with other young artists, photographers, and filmmakers—whether on social media or in person—who suffer from a similar sense of isolation and a dearth of resources.

In 2015, during a contemporary photography festival in Algiers, a five-hour train ride from Oran, Shanan was talking to a handful of artists. Sensing the benefits of working together, they drew up a plan for creating a collective, named 220 after the room in the Hôtel Albert Premier where they met. Collective 220 now has seven members, including Yassine Belahsene, Houari Bouchenak, Youcef Krache, and Sonia Merabet. Together, they are bound by their passion for photography and a desire for greater visibility of art from Algeria, particularly on platforms throughout Africa, such as the Bamako Biennale in Mali (where Krache participated in 2015) and Ethiopia's Addis Foto Fest (which featured Shanan's work in 2016). Shanan describes the collective as a common laboratory, a place for learning, experimentation, and risk. But it's also a communal office for members who bring in varied professional experiences in the fields of advertising, fashion, and film.

"We can share our work and get honest feedback," Shanan explains. "We don't have editors. We don't have really good art critics. We have to be critics for each other." Much of the work of the collective is emphatically practical. When Krache, for example, was working on a project about some of the more dangerous neighborhoods in Algiers, other 220 photographers joined him when he was shooting. But the facts of the collective are also philosophical. "We're a group of people trying to be creative," Shanan says. That means quite a lot in this world these days.

Kaelen Wilson-Goldie is a writer, critic, and contributing editor of the magazine *Bidoun*.

All photographs from the series *Diary: Exile*, Algiers and Oran, Algeria, 2014–16
Courtesy the artist and Collective 220

have found that there is violence in documents. Stamps, visas, and passports segregate more than they unite. In his series *The Lost Chapter: Nampula, 1963* (2016), the family holidays by the beach, lazy afternoons idling behind a newspaper, and seemingly pointless car journeys are burdened by the clutter of heavy-handed bureaucracy. Jasse makes this clear by subverting these photographs rescued from oblivion—images of nonchalant innocence are overshadowed by the fluorescent weight of authority.

These golden, sunbaked moments are snapshots of the beautiful life some anonymous European settlers carved out for themselves in Mozambique. Houses are splendid, smiles abound, and the careful framing renders black servants invisible in the background, reduced to marginal roles in these days of African

DÉLIO JASSE

Silas Martí

conquest. Jasse, who was born in Luanda, Angola, another former Portuguese colony, and moved to Portugal at the age of eighteen, reimagined the photographic compositions by silk-screening onto them the government, bank, and photography studio stamps that had been printed on the backs, like shadows hovering uneasily over a scene. It isn't, however, a subtle move. The standard black used in official labels is replaced here with a vibrant palette of colors, reminiscent of the bold and exaggerated seals of approval used in advertisements.

Jasse came of age in the dawn of a postcolonial reality, and he seems to attack the fragility of borders, physical and metaphorical. He started working in Lisbon three decades after Angola won its independence from Portugal—the European power held onto its colonies on the continent for a long time, and only gave up these territories after violent conflicts. Though the battle ended in 1975, in the artist's work its wounds seem fresh and often resurface. In Portugal, Jasse spent years attempting to become a legal resident until finally sorting out his papers. *The Lost Chapter* reflects the artist's own struggle with trying to find acceptance in the realm where it now seems to matter the most, that of files, government backrooms, and databases.

"I never had a second nationality, there were too many bureaucratic flaws in the process," says Jasse. In a time when there are more migrants and displaced people than at any other point in history, Jasse's reflection on divisiveness during the meltdown of globalization couldn't seem fresher.

Opposite:
A Minha Casa, 2016.
Cyanotype on Fabriano paper

Pages 118–23:
The Lost Chapter, Nampula, 1963, 2016.
Photographic emulsion and screenprints on Fabriano paper
All works courtesy the artist and Tiwani Contemporary, London

Silas Martí is an art critic based in São Paulo, where he is a visual arts writer and columnist at the newspaper *Folha de S.Paulo*.

Eric Gyamfi

M. Neelika Jayawardane

On March 6, 2017, Ghana, the first sub-Saharan country to gain independence in Africa, marked sixty years of freedom from British colonial rule. Despite its pioneering political history, proud anticolonial tradition, and impressive cultural and intellectual heritage, Ghana's laws still reflect British colonial obsessions with regulating bodies and criminalizing sexual expression. So-called offenses are punishable on conviction by up to three years in prison. From the pulpit of churches and law lecterns at universities, fanned by heavy lobbying and funding from U.S. evangelical Christian groups, Ghanaians hear calls for "blistering crusades" against gay people.

Since the beginning of his career, the photographer Eric Gyamfi has focused on individuals who have endured marginalization and exclusion. Gyamfi trained at Nuku Studio, founded by Nii Obodai, which facilitates workshops for photographers. Yet Gyamfi's journey as a photographer began with explorations of the self: he recreated memories from his childhood, where he positioned himself within the reenacted dramas of his photographs. These reenactments allowed him to view himself, as well as the social conditions that produce contemporary notions of Ghanaian gender, sexual identity, and masculinity.

His project *Just Like Us* (2016), supported by the Magnum Emergency Fund and shown earlier this year at the Nubuke Foundation in Accra, explores the contradictions of queer life in Ghana and chronicles what it means to be "other" in a nation of people who have a remarkably well-defined sense of what binds them together. Gyamfi is motivated by the threat of LGBT people being eliminated from the archive of Ghanaian memory. If narratives about queer lives are not regarded as part of Ghana's ordinary everyday, a significant section of Ghanaian history will, as he says, "vanish." His quiet images underscore the reasons why it is imperative to record, produce an archive of, and exhibit—to share in the open—the experiences of queer individuals in contemporary Ghanaian society.

Just Like Us is the beginning of an open-ended project, a chronicle of the lives of Gyamfi's queer friends and acquaintances, whom he calls "participants." Gyamfi wants to emphasize the ordinariness of queer life, and that there are, in fact, many ways of being queer. We see images of interior selves, and of the poetic longing to belong; we see people's dreams, motivations, and the intersection between their desires and their identities. "It was about so many things other than photographing people's sexuality," Gyamfi says. "It was about people as people first."

He lived with his friends, hijacking their couches and guest rooms, staying with them for weeks, even months, so that he could be present as they shopped for groceries, worked out differences in their long-term, monogamous relationships, or did something fun with a platonic friend. The friendships between queer and straight people are also a running theme, showing the significance of support systems. His participants must contend with the fact that being recognized as gay means that their persons and bodies will be open to carceral punishment and social policing.

Even as some queer people live openly in Ghanaian society, they may face both mental dislocation and physical displacement from home if their families reject them. Reflecting on one image of a young man whose face and body are turned away from the camera, his shoulders hunched with palpable dejection, Gyamfi says, "I was walking this young man home one afternoon and he said to me, 'Eric, eventually I will have to live as a straight man.' This was a queer man who, as a result of societal pressure, or familial pressure, could end up having to live as a straight man." For Gyamfi's participants, self-exploratory journeys are less a luxury, and more an endurance tool. And while creating a record of the ordinary may not seem like a necessary act, given the incendiary rhetoric of the present moment, Gyamfi's work is an act of survival.

M. Neelika Jayawardane is Associate Professor of English at the State University of New York–Oswego and Senior Editor of the online magazine *Africa is a Country*.

Some of the LGBT community members organize a night of dance and performance for themselves after the international day against homophobia and transphobia event as a way to get to know other community members and to network.

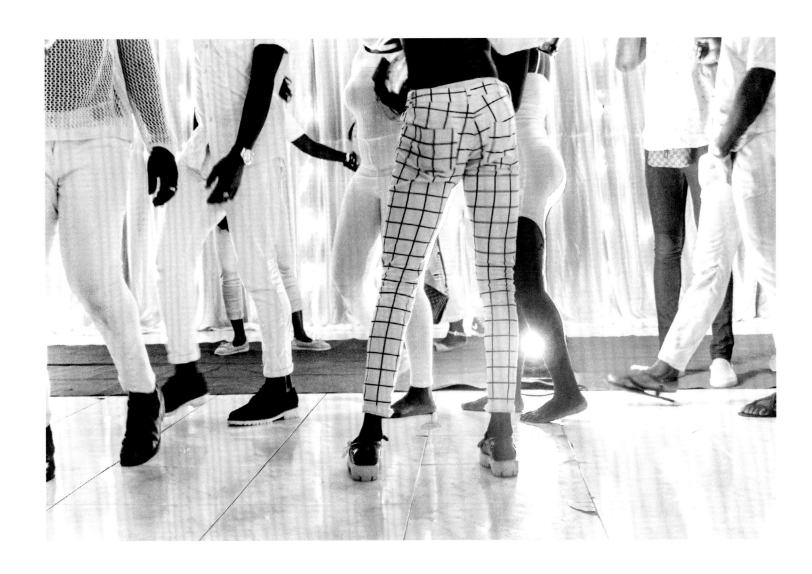

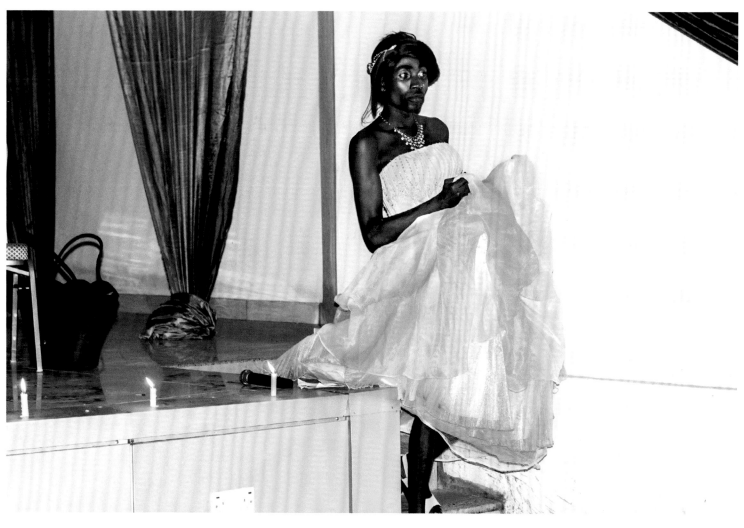

Opposite, top:
Henry performing in drag.

Opposite, bottom:
Henry goes through some old photos. In 2011, Henry was married, and he got divorced in 2015. Henry has a son from this marriage, who is currently in the care of Henry's mother (his son's grandmother).

This page:
Kwasi and Annertey find the Akaa Falls. Kwasi, looking to start a magazine on Ghanaian tourism, explores the eastern regional landscape of Ghana with his friend, Annertey, for new places to feature in the debut issue of his magazine. Kwasi identifies as a gay man, Annertey as a straight man.

Henry and his boyfriend, Mingle.

"Someday, soon, I'd have to live as a straight man,"
Jay laments, one Thursday afternoon after school
as we walked. "I think about that every day." Jay
identifies as a gay man.

All photographs from the series *Just Like Us*, 2016
Courtesy the artist

François-Xavier Gbré

Tracks

Sean Anderson

What is a ruin? For the photographer François-Xavier Gbré, born in Lille, France, to a French Ivorian family, architectural ruins are manifestations of nefarious ambition. Growing up in the 1980s and 1990s in a city where the dominant textile industry was in decline, his first photographs articulated conditions of loss and its effects on the built environment. Gbré trained in commercial photography in Italy and France before relocating in 2010 to Bamako, Mali, and later to Abidjan, Côte d'Ivoire. His technical precision, refined on behalf of clients such as *Elle Decor* and *Casa Vogue*, is evident in his ongoing photographic essay *Tracks*, begun in 2009, an account of decaying urban landscapes in European cities and former colonial capitals in West Africa.

"On a CD or vinyl record, you have different tracks, different songs," Gbré said in 2015. "The tracks can be the roads, the railway, the traces left by imprints." He began to photograph the vestiges of the former Unilever and Poyaud factories in northern France in 2010, and these became the first part of the project. Each chapter of *Tracks*, he says, tells a different story, and, depending on how he configures each section, might include photographs from France, Israel, Mali, Togo, Benin, Côte d'Ivoire, or Senegal. The most recent "track," made in 2014, explores the Palais de Justice in Dakar, an abandoned modernist courthouse that Gbré returned to for the installation of his work *I Am African* in the 2016 Dak'Art Biennale.

Whether of a former printing factory in Benin, a governor's palace in Togo, or a rooftop in Senegal, Gbré's photographs in *Tracks* reveal the often unseen edges of cities, and challenge how we are implicated by the afterlives of the colonial past. Gbré observes the shifting paradigms of modernity with regard to memory. From an empty lot in contemporary Abidjan, one's view of a suburban tract house or a solitary car in a protective covering presents shared conceptions of security, haunted by aspiration, yet seemingly dispossessed. The value of objects is

questioned, as much as evolving. Gbré's photographs register an uncertain interconnectivity amid careful details—a contract that maps and contains collective desire.

Parallel to these investigations, Gbré's engagement with a number of arts events and platforms across the continent— the Bamako Biennale, the Kulte Gallery & Editions in Rabat, Art Twenty One in Lagos, and Galerie Cécile Fakhoury in Abidjan—reflect a desire to see these visual and spatial provocations as an affirmation of the artist's capacity to deepen authorial identities today. To claim an all-encompassing "African imaginary" here bespeaks an erasure of boundaries, but perhaps this is the idea? Similar to Gbré's process, the interventions of a new generation of photographers—Mame-Diarra Niang in Senegal, Edson Chagas in Angola, Mikhael Subotzky and Dillon Marsh in South Africa—identify both stage and screen for the pitfalls of the states' profligacy.

Gbré's scenes are doubly suspended: first, as components within a legacy of (post)colonial intervention; and second, as records of estrangement. His installations, which range from constellations of numerous small images to immersive wallpaper prints, reference oblique narratives across multiple sites. Like a shallow puddle of water magnifying a history—or an unwanted truth—so, too, a skylight or a disused Renault does not disclose enough information.

Unlike the architectural magazines for which Gbré once photographed, the spaces of *Tracks* cannot easily be consumed, or discarded. Instead, they must be interrogated. *Tracks* is Gbré's history lesson. Whether delayed, confined, or indeterminate, these near instinctual images signal how spatial metaphors do not quite satisfy a pretext for navigating complex histories that are in the process of being unmade. Referring to the Dakar seafront he photographed in the midst of construction—a public vista soon to be a private one—Gbré has spoken about the uncertainties of so-called progress and the false resolution of urban symbols. "One landscape is moving ahead," he says, "but there's also one that's disappearing."

Sean Anderson is Associate Curator in the Department of Architecture and Design at the Museum of Modern Art, New York.

Cité Espérance #2,
Route de Bingerville,
Abidjan, 2013

Thomas Boni Yayi,
Président de la République
du Bénin, Imprimerie
Nationale, Porto-Novo,
2012

Baie de Mermoz II, Dakar, Senegal, **2012**
All photographs courtesy
the artist and Galerie Cécile
Fakhoury, Abidjan

1:54 Contemporary African Art Fair

www.1-54.com
@154artfair

New York City
Pioneer Works
May 5–7, 2017

London
Somerset House
October 5–8, 2017

Marrakech
La Mamounia
February 23–25, 2018

PRINTED WITH
PRECISION AND
CARE BY
OFSET YAPIMEVİ

ofset.com

facebook.com/ofsetyapimevi

OFSET
YAPIMEVİ

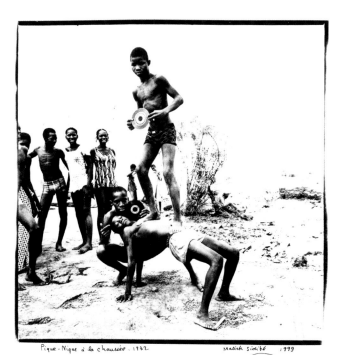

Aperture Beat

Stories from the Aperture community—
publications, exhibitions, and events

Mickalene Thomas

While Mickalene Thomas is best known for her lush, rhinestone-covered panel paintings of people and domestic interiors, photography has long been at the core of her work. As a student at Yale she began photographing herself—and her mother—as artistic muses such as Édouard Manet's odalisques, model Beverly Johnson in her iconic fashion shoots, and Malick Sidibé's stylish Malian club-goers. A traveling exhibition gathers Thomas's photomontages, C-prints, and Polaroids, accompanied by an installation, *tête-à-tête*, in which Thomas pays homage to her photographic community of influences, including LaToya Ruby Frazier and Carrie Mae Weems. This exhibition, organized by Aperture Foundation, will be on view at the Virginia Museum of Contemporary Art, Virginia Beach, from May 12 to August 13, 2017, and then travel to the Georgia Museum of Art, Athens; the Pomona College Museum of Art, Claremont, California; and the Dayton Art Institute, Ohio.

Mickalene Thomas, *Quanikah Goes Up*, 2001/2005
© and courtesy the artist; Lehmann Maupin, New York and Hong Kong; and Artists Rights Society, New York

The Style Issue

Aperture's fall issue will explore sartorial politics and how social engagement can be expressed through self-presentation and fashion. From Kwame Brathwaite's 1960s photographs that championed the transformative slogan "black is beautiful" to Collier Schorr's recent campaign for Saint Laurent, the issue will unpack the intersections of style, identity, and self-expression.

Kwame Brathwaite, *Untitled (Sikolo)*, 1968/2016
Courtesy Cherry and Martin, Los Angeles

Claude Iverné

Starting in 1998 and continuing for close to twenty years, French photographer Claude Iverné traveled along the path of the Darb al-Arba'in (Forty Days' Road), an ancient trade route that in medieval times transported gold, ivory, and slaves from Sudan to Egypt's Nile valley. On the road and along the banks of the Gazelle River, Iverné documented nomadic farmers, families journeying by camel, barbershop windows, and displaced persons camps in intimate and striking black-and-white and color photographs that redraw the contours of contemporary South Sudan. Images from the project, for which Iverné received the 2015 HCB Award, will be on view at the Fondation Henri Cartier-Bresson, Paris, from May 11 to July 30, 2017, and at the Aperture Gallery, New York, from September 15 to November 9, 2017.

Claude Iverné, *Seventh Day Adventist Secondary School, Hai Kuwait District, Juba*, 2015
© the artist/Elnour

Rinko Kawauchi

"Everything seems like dust, hazy in the gloom," Rinko Kawauchi writes in her new book, *Halo*, a dazzling visual meditation on cycles of nature, time, and ritual. Halos appear everywhere: in the stars and clouds, in snowfall and rain; in the flight of migratory birds near the coast of Brighton, England; in the sacred flames lit on the beach of Inasano, Japan; in a village in the Hebei province of China where, in lieu of fireworks, Chinese New Year revelers hurl balls of molten iron at the city walls, as they have done for more than three hundred years.

Rinko Kawauchi, from *Rinko Kawauchi: Halo*
(New York: Aperture, 2017)
© the artist

Stephen Shore

"The photographs in this book were made by me so long ago that I often have no memory of their making," admits Stephen Shore, who, in order to cull images for *Stephen Shore: Selected Works, 1973–1981*, revisited much of his own work from his seminal project, *Uncommon Places* (1973–81), "with the detachment of an observer." A group of fifteen curators, writers, cultural figures, and photographers, including Shore himself, were invited to select ten photographs from an archive of some four hundred images of Shore's sprawling travels through mid-1970s America, some of which have never been previously shown. Wes Anderson adds his own captions; Lynne Tillman draws connections to the poetry of Wallace Stevens. Of his own selections, Ed Ruscha notes, "I seem to have favored scenes that were oblivious to the viewer or forgot they were even there."

Stephen Shore, *Texaco Station, Dixie Highway, West Palm Beach, Florida,*
November 9, 1977
© the artist

Feast for the Eyes

Long before there was food porn, there was food photography. *Feast for the Eyes* is the first book to explore its rich and varied history and examine the photographers who sought to describe food in pictures. Images of food—whether characterized in the wit and beauty of an Irving Penn photograph, in a seemingly ordinary diner tableau by Stephen Shore, in Sarah Lucas's *Self Portrait with Fried Eggs* (1996), or in a Betty Crocker cookbook illustration—are never just about food, writes editor Susan Bright, but can depict "our dreams and desires."

Elad Lassry, *Untitled (Red Cabbage 1)*, 2009
© the artist and courtesy 303 Gallery, New York

Object Lessons
Self-Portrait by Chief S. O. Alonge, Benin City, Nigeria, ca. 1942

"He was a very well-dressed man," Regie Alonge, son of Solomon Osagie Alonge, the first official photographer to the royal court of Benin, Nigeria, recalled. "Everyone knew him for that. He was always wearing a suit." Across a career spanning sixty years, from the 1930s to the 1990s, Alonge (1911–1994) photographed politicians, ceremonies, and festivals. In 1942, he opened the Ideal Photo Studio in Benin City. "Just a one-man business," his son, who now lives in New York, called it, although there was always a flurry of apprentices and assistants. "We developed print photographs in the darkroom with our hands. No gloves!"

For some of Alonge's subjects, a visit to Ideal Photo Studio marked their first time being photographed. "Alonge provided local residents with the opportunity to represent themselves as dignified African subjects," said Amy Staples, an archivist at the Smithsonian National Museum of African Art and cocurator of a 2014 exhibition about Alonge. His subjects, like those of the celebrated Malian photographers Seydou Keïta and Malick Sidibé, often selected their own outfits and decided how they wished to pose for the camera.

As the court photographer for the *oba*, the traditional ruler in Benin of the Edo people, Alonge made portraits of Oba Akenzua II (1899–1978), who was known for reinstating traditional cultural practices forbidden under British colonial rule. Images of Akenzua II by Alonge, as well as his court photographs from the 1930s, were reproduced on commemorative cloths decades later, a testament to both Alonge's work and the value placed on photography in Benin.

Alonge was revered in Nigeria for his honest, sincere personality, which extended into his graceful photographs. In July 2017, marking a historic collaboration with the National Commission for Museums and Monuments in Nigeria, elements of the Smithsonian exhibition, including framed photographic reprints, text panels, murals, and banners, will be installed in a permanent exhibition at the Benin City National Museum. A witness to the social world of twentieth-century Nigerian society, Alonge was a keeper of history, both personal and political. —**The Editors**